Copyright © 2016 Textile Study Group of New York

ISBN: 978-1534938410

All rights reserved.

Textile Study Group of New York
http://tsgny.org
info@tsgny.org

P.O. Box 3592, Grand Central Station, New York, NY 10163

YARD WORKS

An exhibition of works by members of the

Textile Study Group of New York

Durst Lobby Gallery
1133 Avenue of the Americas
New York, NY

September 21 – November 16, 2016

INTRODUCTION

Orson Welles once famously said, "The absence of limitations is the enemy of art." (1992 The Movie Business Book) Given the ever-widening plethora of choices in process and materials within textile arts today The Textile Study Group of New York has challenged twenty-one artists to bring this abundance of riches into focus by working on a stretched canvas measuring exactly thirty-six inches (the standard measurement for one yard) in length (varying in width from twelve to thirty-six inches). The mixed media pieces included in Yard Works encompass a wide range of materials from copper wire and acrylic paint to linen and grass, to the more traditional mediums of fabric and thread. Largely abstract in nature, the works explore the possibilities that lie within a restricted space.

The colorful works of Jane Broaddus and Elisa Caporale offer macro views of organic forms. Broaddus's Permian Tide Pool Party is a mix of cotton fabric, yarn, embroidery thread, beads, buttons, and broken jewelry that create a bas relief. Large to small donut shaped forms in an array of pastel colors embedded in undulating rows of stitches mimic the crustaceous forms and jewel-like colors of the coral reef. The melding and morphing pools of ringed pink, blues and reds in Caporale's Coloreyes flow as one unified organism.

Nancy Koenigsberg's and Kim Svoboda's works speak to the structural realities of textiles, from the fused and stitched fragments of wool felt, tulle, cotton and silk in Svoboda's Between Heaven and Earth to the crisscrossed copper wire of Koeningsberg's Crosspurposes. Both

artists are randomly arranging materials that, in their multiplicity create a new fabric of their own. Crosspurposes becomes a circuitous highway of parallel and oblique lines that intermittently meet in star-like hubs of interconnectedness, an apt metaphor for human interaction. The black and white scraps of Between Heaven and Earth act as white noise bifurcated by branch-like shoots that connect both the top and bottom of the artwork. At the top, a line of red lies parallel to a line of black creating a border beyond which red fabric scraps accumulate in mass. The lines are overlapped by a curiously bird-like grouping of white fragments which break away from the central flock. Three quarters down the fiber painting a horizontal grouping of black pieces act as a distant landscape above the red ground plane that is minimally represented at the bottom of the composition.

A certain vibrational resonance is set up in the works of Cheryl Gerhart (Ebb Tide), Susan T. Edmunds (Garden in Winter), Larry Schulte (Colors of the Southwest) and Yasuko Okamura (Spirits in the Desert). Gerhart's shibori-dyed willow pattern and Okamura's woven and dyed wool roving flow in a similar palette of blue and white, shifting in an echoing rhythm of light and color, while Schulte's bold blues and fiery reds and oranges, painted in acrylic on paper and woven in strips, push back and forth in a pixilated interplay of foreground and background. Edmund's encapsulates stems of grass and a flowering plant in a frame of squares with a circle center (woven in wool), giving the impression of viewing reverberating shafts of sunlight through a French window.

Further examining the metaphor for light, Gail Miller's Reflections of the Day, is painted in a thin wash of yellow and green acrylic paint interrupted by rays of green and orange thread in

horizontal lines and pointing darts. Saaraliisa Ylitalo's Empty appears as a large indigo sun, created with joomchi shibori on mulberry paper. Three small squares of gold leaf in the right corner accent the piece. Lastly, Barbara Schulman's May Your Hands Always Be Busy is a cotton and rayon mosaic of interlocking parallelograms, quilted in fiery reds, oranges and hot pinks, they mix with areas of black in which hands, single and in pairs, remind us of that old adage, "Idle hands are the devils workshop."

Through various levels of multiplicity the artists Valerie Zeman (Summer Traffic), Julia Kiechel (Outlook), Kathy Velis Turan (Intersections 12), and Marilyn Henrion (Patchwork City 28) invite us to look into, out of and onto urban patterns. Henrion's employment of one smaller canvas mounted upon a larger one reinforces the effect with hand quilted city windows that reflect the blue sky while partially covering layers of architectural collage all printed on silk and linen, giving a space to breathe in the metropolitan mix. Zeman appears to be taking a closer look, using pure abstract rectangular forms hand-dyed in salmon pink, acid green and neutral black and grey (interrupted by only one strip of bright red on the right hand side) reminiscent of Gee's Bend quilting patterns. Turan's painted cool and warm greens, are covered with lace-like structural grids and overlapped by monumental girders in various tones of grey embellished with beads and stitching. The effect is one of looking through the trusses of a steel bridge. Keichel also employs layers though in actual three dimensional form. Warm, neutral grey hand-cut felt imitates the grids of towering skyscrapers, the shadow play giving depth to this simple relief.

Margaret Cusack stands alone with her representational landscape garden plan, Behold the Hostas in Our Backyard created from fabric, thread and canvas. Her lush greens, grey stone garden path and decorative furniture feel like an oasis from urbanity.

Deborah L. Brand, Rodica Tenenbaum, Linda G. Parker, Susan Ball Faeder and Kathryn Kosto have chosen to approach the challenge through employing mixed media collage techniques. Kosto's formal arrangement of clothesline, repurposed clothing, sewing patterns, acrylic paint, pastel, buttons, and findings in laundry list descend in an almost scriptural tapestry in homage to the quotidian, creating a rhythmic design of repeated groupings of clothespins and a paper pattern whose lines become the symbol for a house. Parker's Belonging contains a random mélange of floral and dotted kantha cloth accented by two decoratively sculptural elements constructed from cologne boxes, plastic packaging and beads. Faeder's Homage to Shizu is similar to Parker's in its combination of flat form with structural elements, made of cotton rags, acrylic paint, and found objects (shells, beads, yarn, etc.). It includes a paper with Japanese writing. Faeder has chosen to include the canvas echoing her woven tapestry in stripes of paint.

Brand and Tenenbaum also lean towards literary interpretation. Tenenbaum's Shards literally uses text on fabric that divides two sides of a symbolic vase, one decorated with a garden pattern filled with birds and the other repeated stitched rows of red, light blue and teal. The central image is intersected by a yellow thread, which originates from each corner of the canvas. Minimal in its presentation, it becomes a sort of haiku on its own, accented with a bit of red tulle and a twig. Brand employs birds hovering around a central mass above which hangs a cloud

hiding a yellow sun, all arranged on a pastel background and constructed out of assorted paper, steel wool, a lampshade, lace, a bicycle gear, antique fan parts, and glass beads.

From this multitude of interpretations it can be seen that for the Textile Study Group of New York the size limitation put upon them with this conceptual exhibit, Yard Works, is far from limiting. In many ways it is obvious that the restrictions gave a challenge to each artist that they were able to meet and while acting as a community of one express their individual voices. Using diverse materials they stepped outside of the box, or yard as one would have it, and created worlds and languages within this restricted universe.

<div style="text-align: right;">Kim Power, July, 2016</div>

Kim Power is a freelance art writer for The Brooklyn Rail, Art Pulse, Arte Fuse and Quantum Art Review. She is a mixed media artist creating mythological dreamscapes that explore the relationships of form and ornamentation.

YARD WORKS

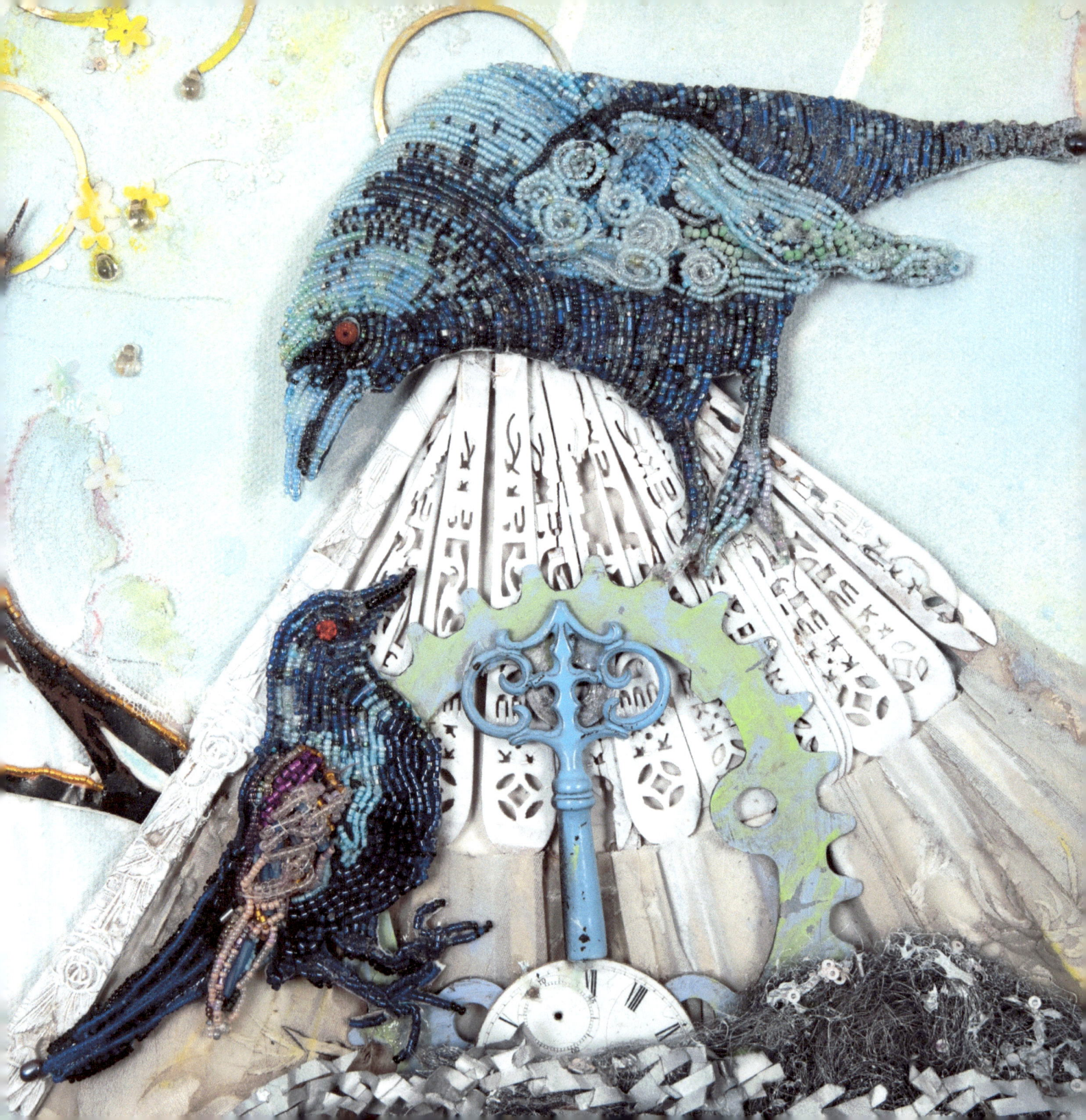

DEBORAH L. BRAND

http://deborahlbrand.com deleebra@gmail.com

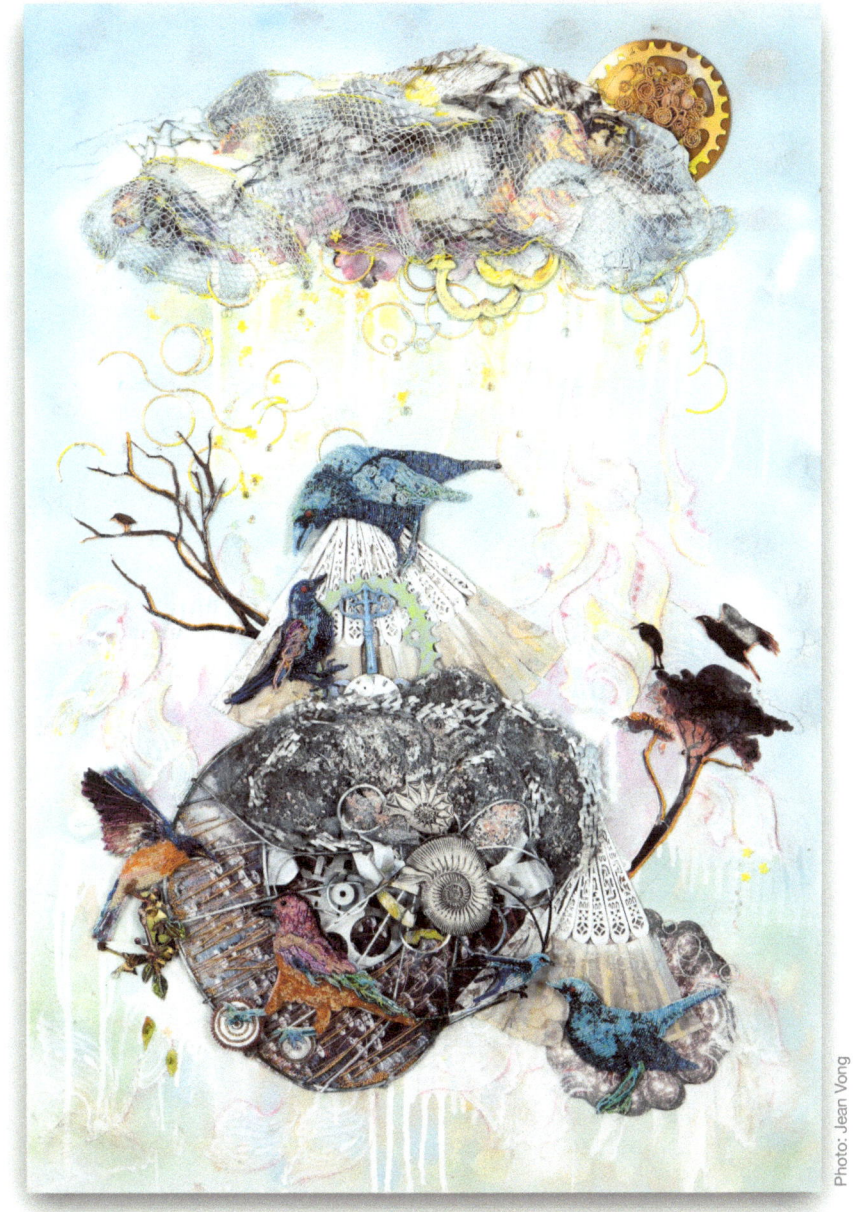

Out On A Limb

36"x24" paper, steel wool, lamp shade, lace, bicycle gear, antique fan, glass beads

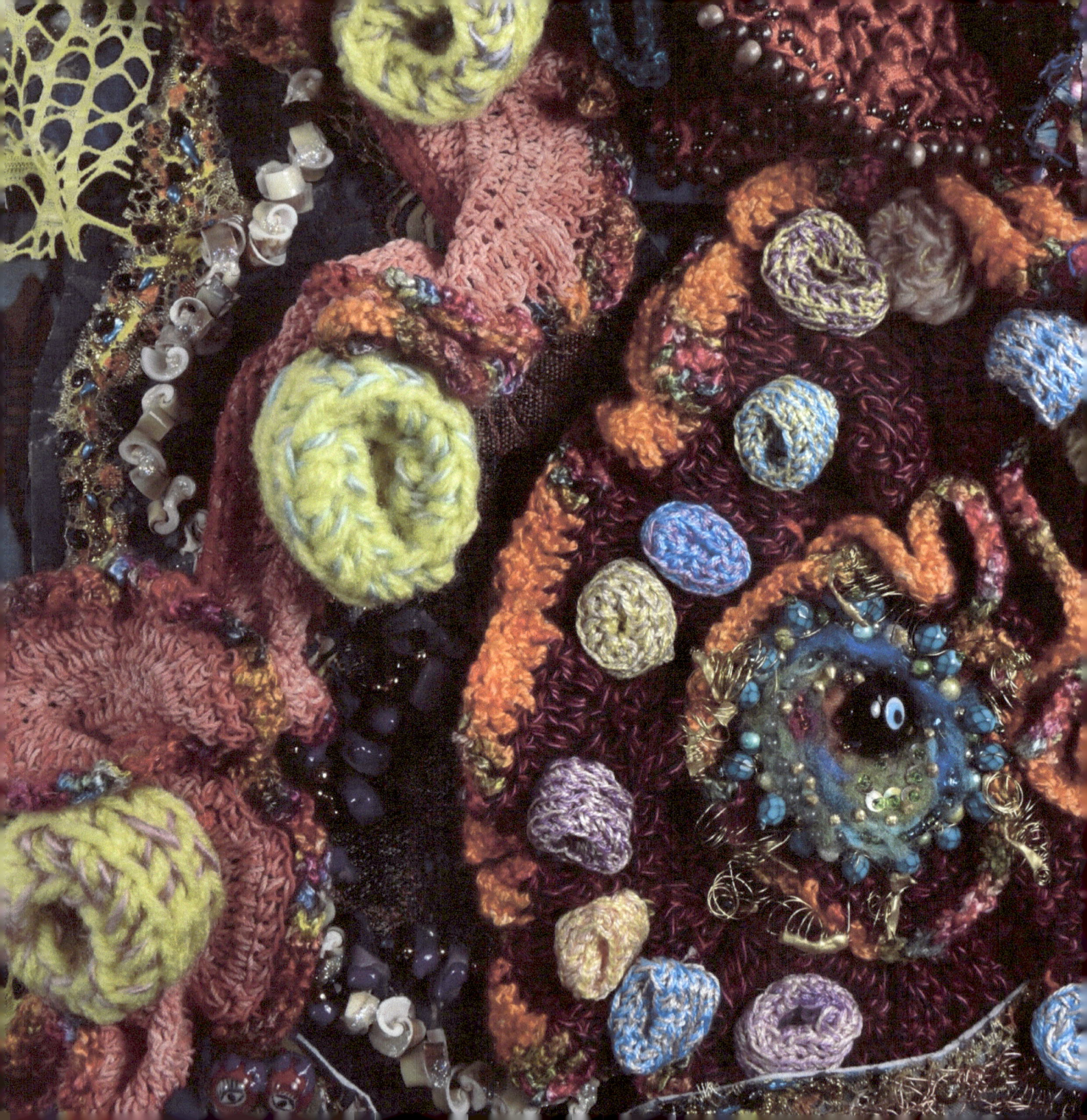

JANE BROADDUS

http://janebb-fiberplus.blogspot.com janebroaddius@gmail.com

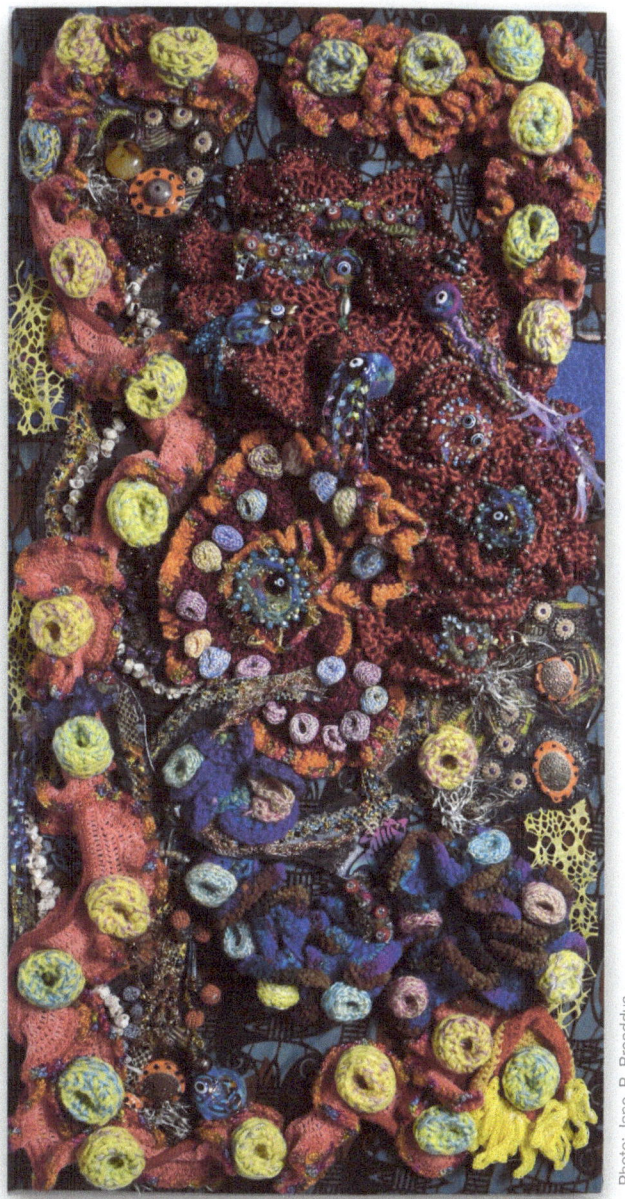

Permian Tide Pool Party

36"x18" cotton fabric, yarn, embroidery thread, beads, buttons, broken jewelry

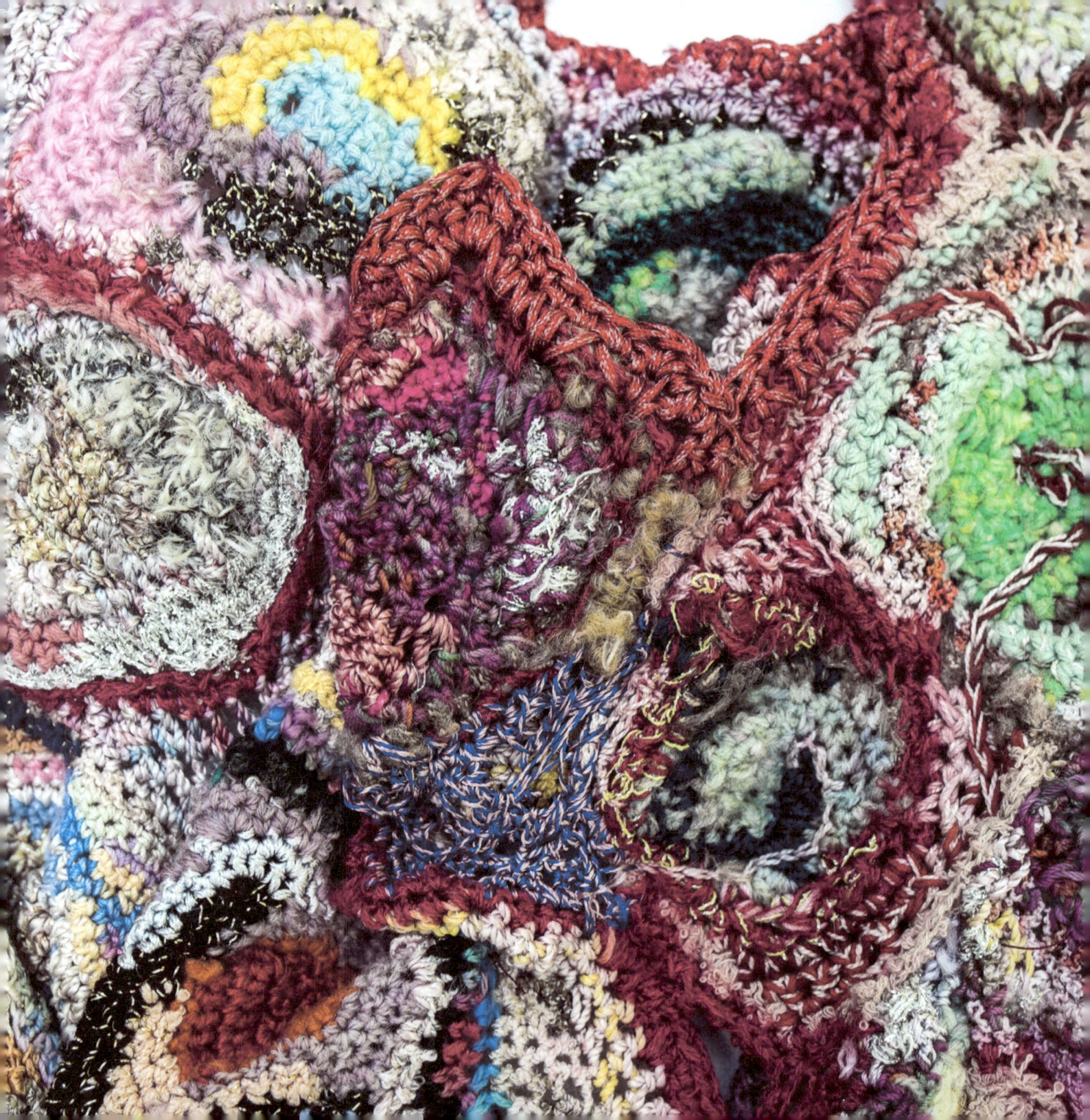

ELISA KESSLER CAPORALE

ecaporale@att.net

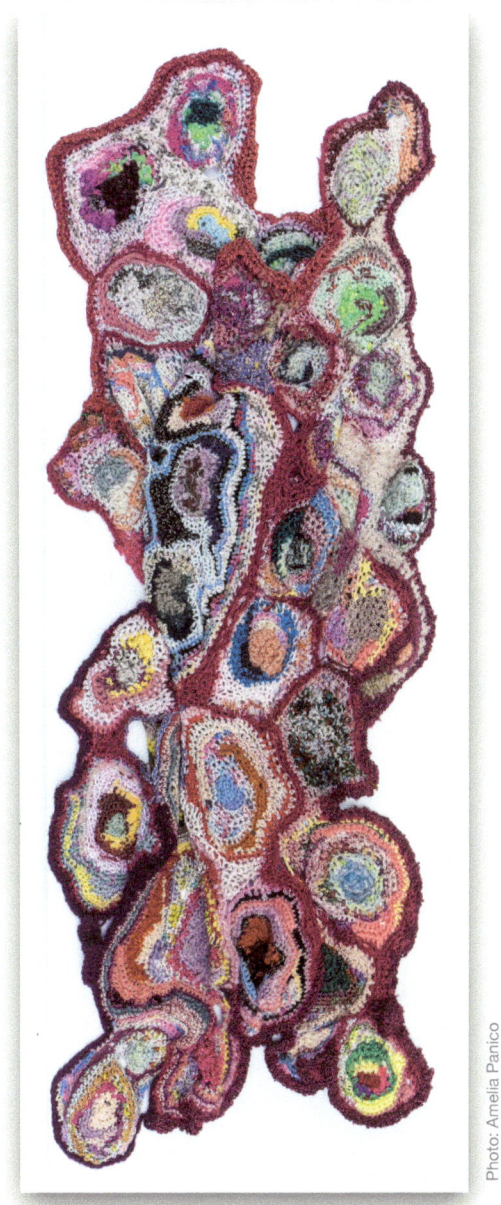

Coloreyes

36"x12" cotton, silk, wool, crocheted works

Photo: Amelia Panico

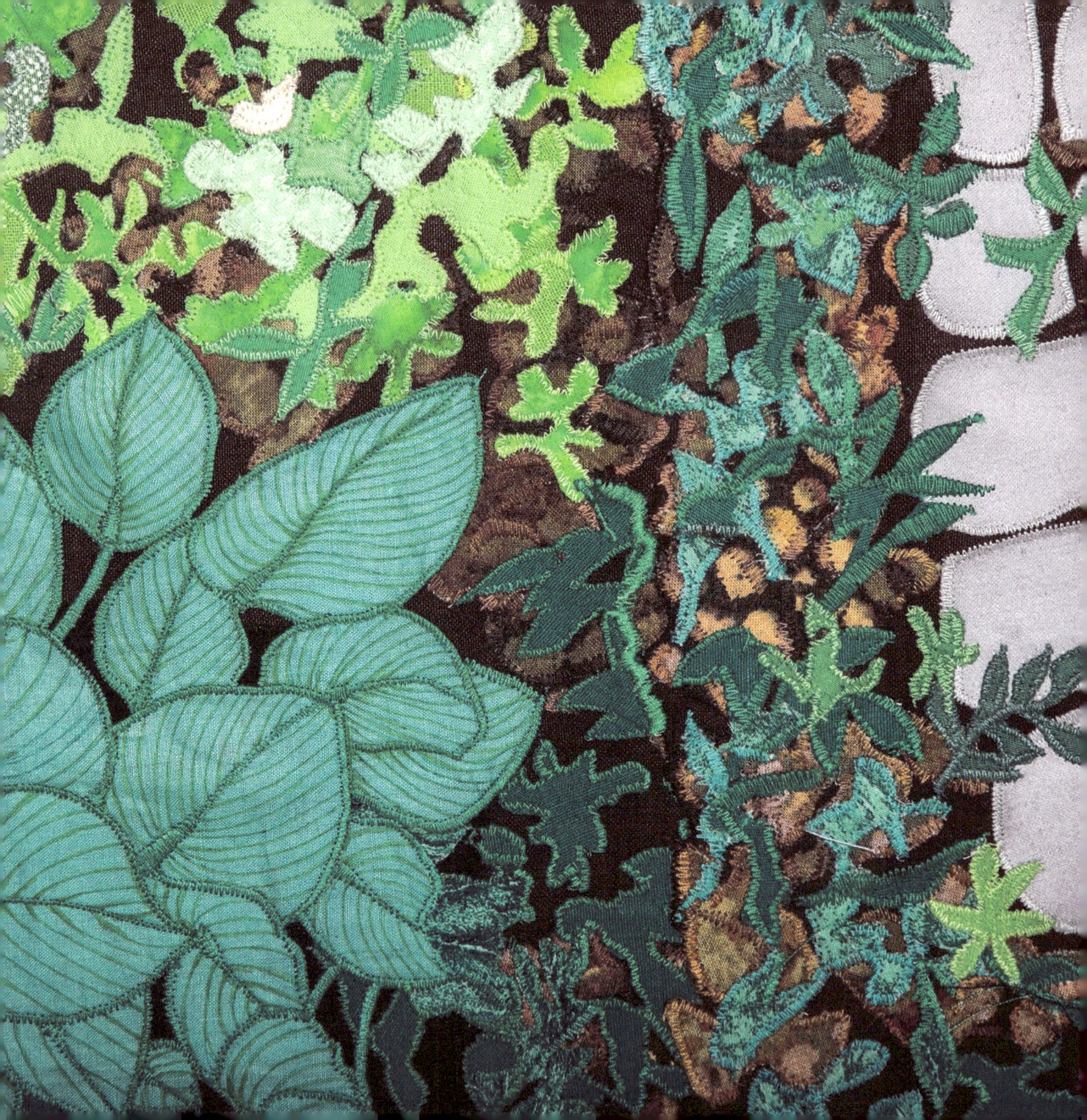

MARGARET CUSACK

http://margaretcusack.com cusackart@aol.com

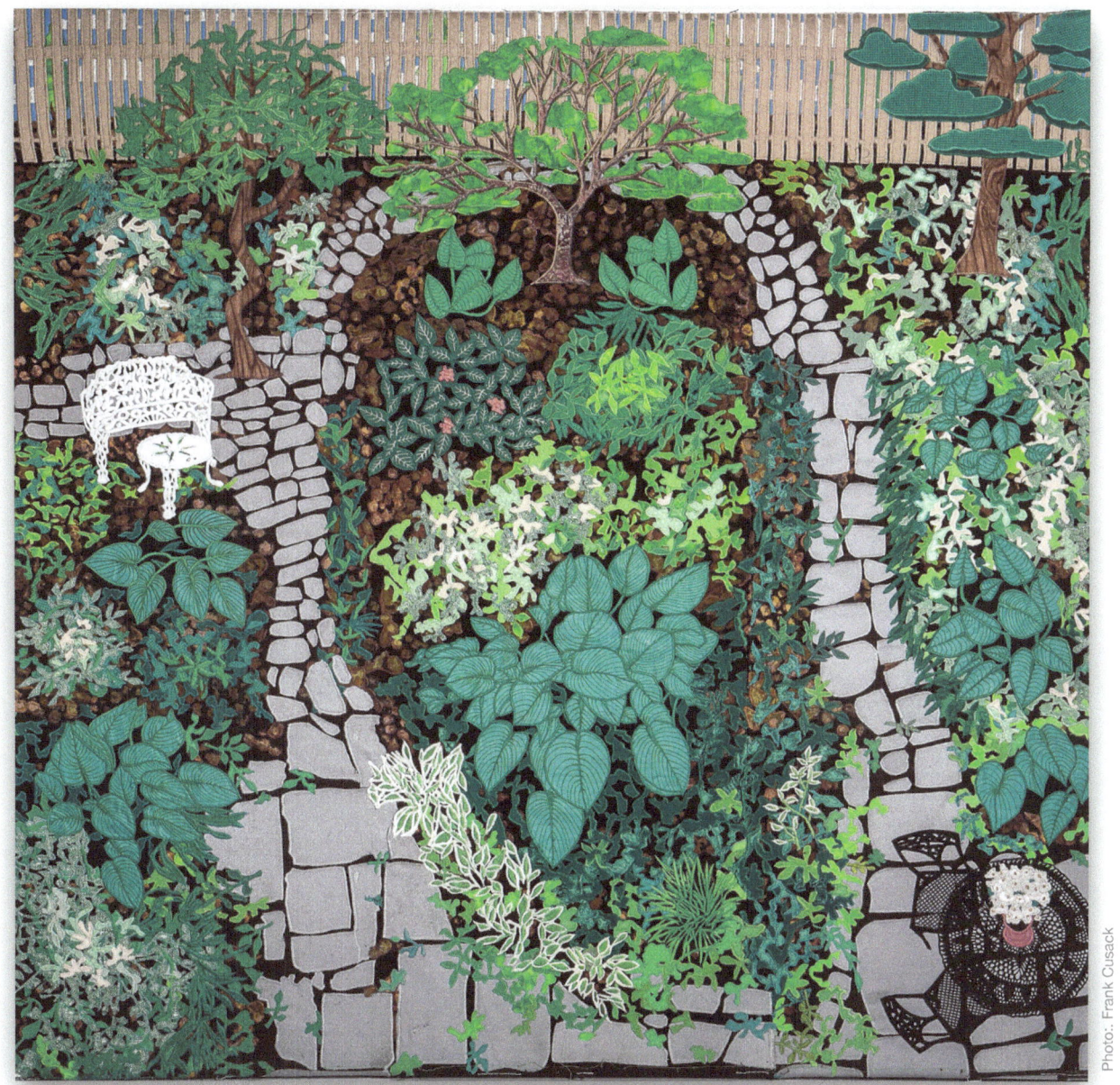

Behold the Hostas in Our Backyard

36"x36" fabric, thread, canvas, stretchers, staples

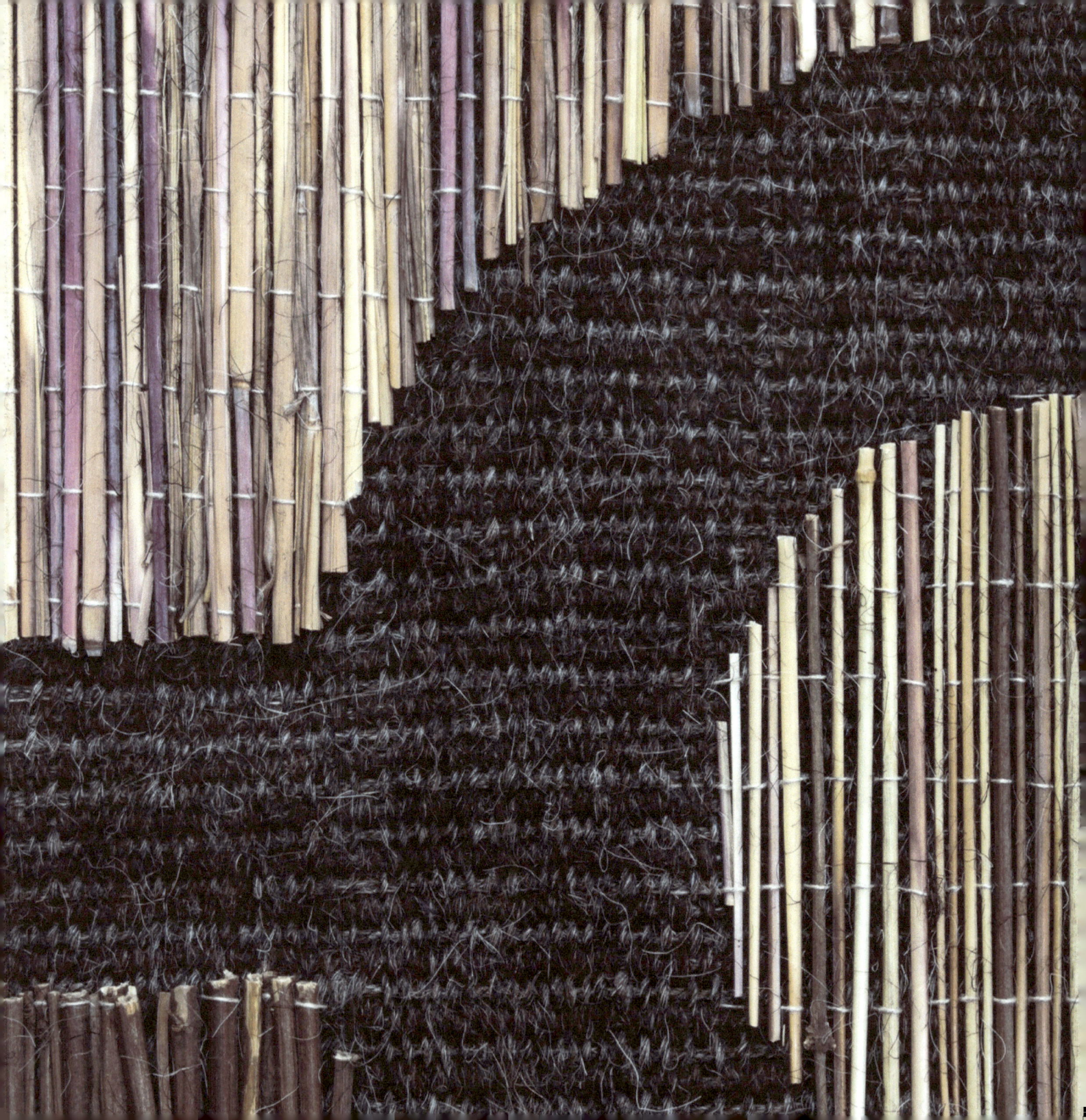

SUSAN T. EDMUNDS

susantedmunds@gmail.com

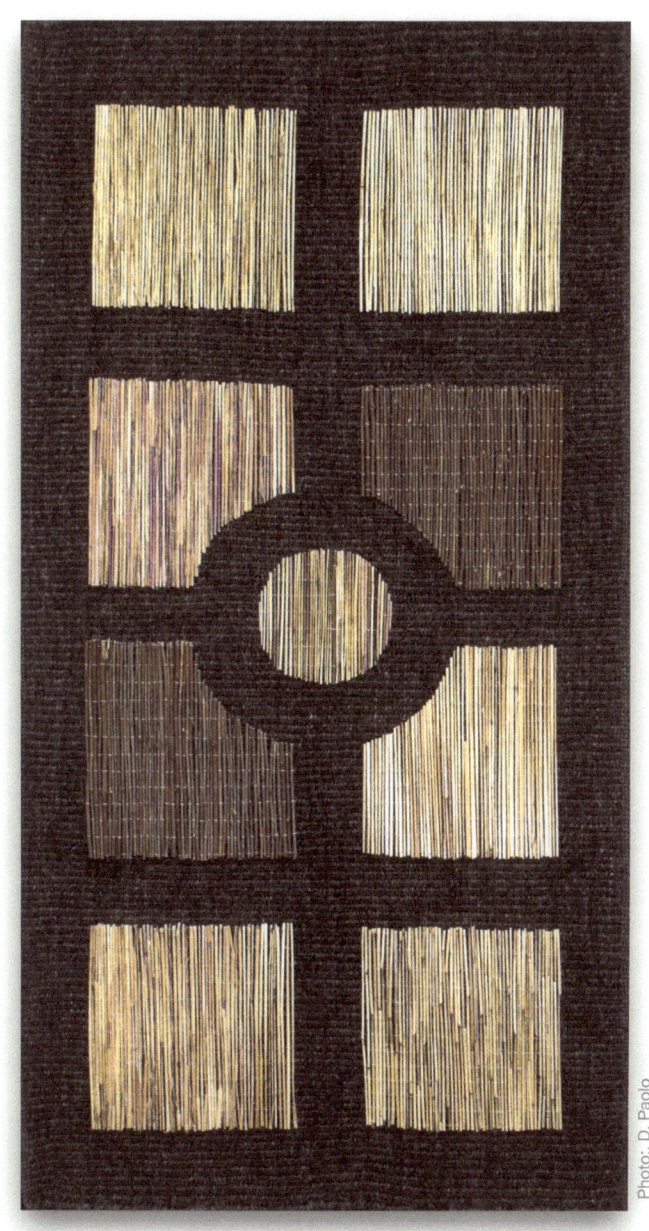

Photo: D. Paolo

Garden in Winter

36"x18"" wool, linen, stems of grasses and a flowering plant

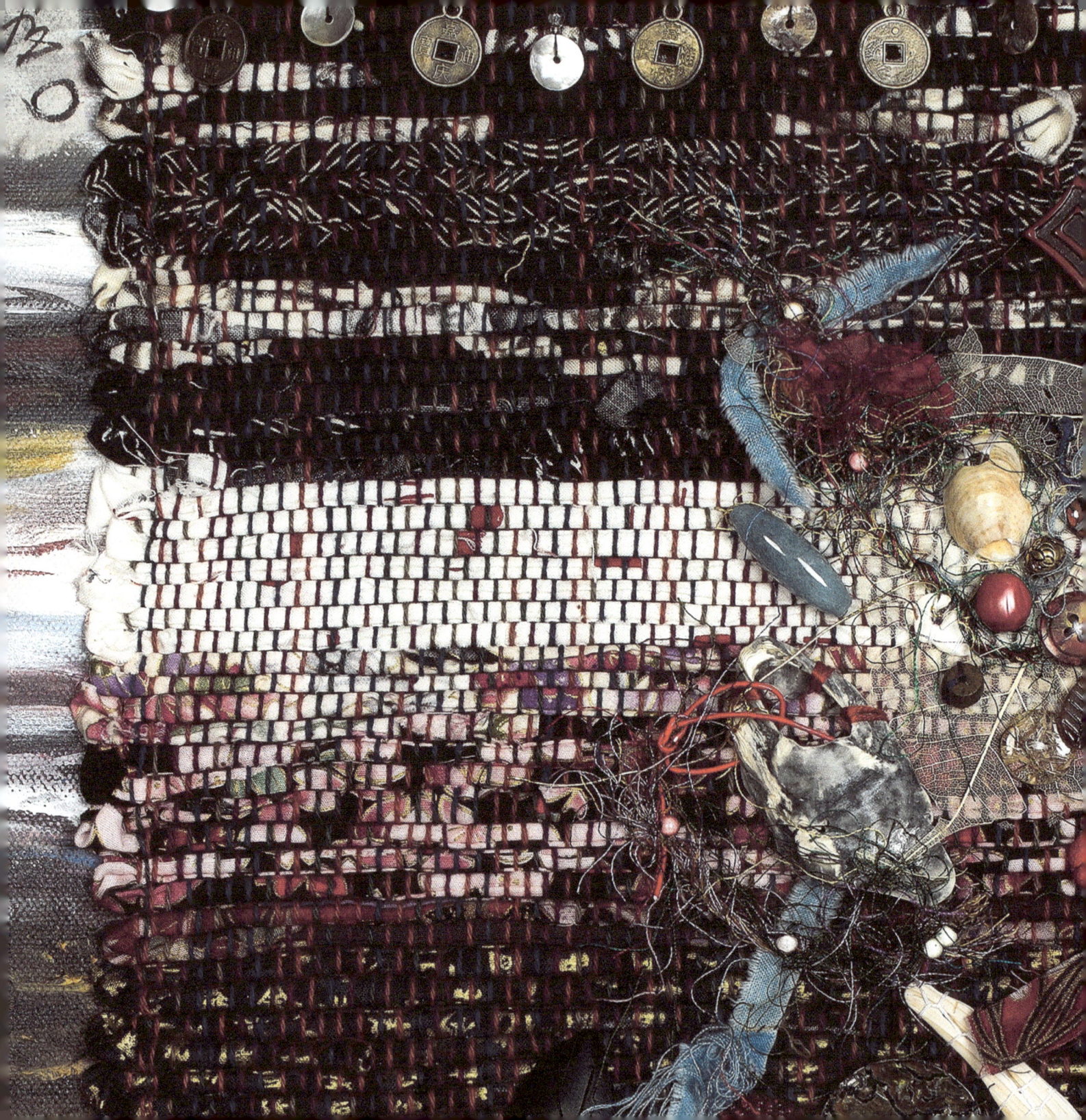

SUSAN BALL FAEDER

http://qejapan.com susan@qejapan.com

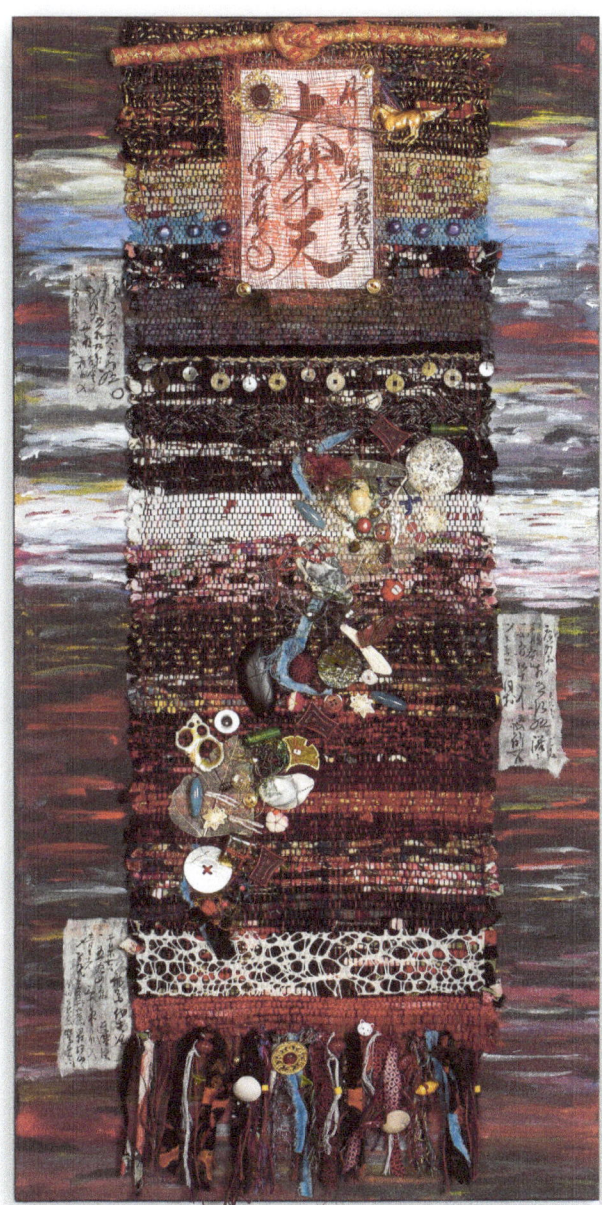

Homage to Shizu

36"x18" cotton rags, acrylic paint, paper, found objects (shells, buttons, beads, yarn)

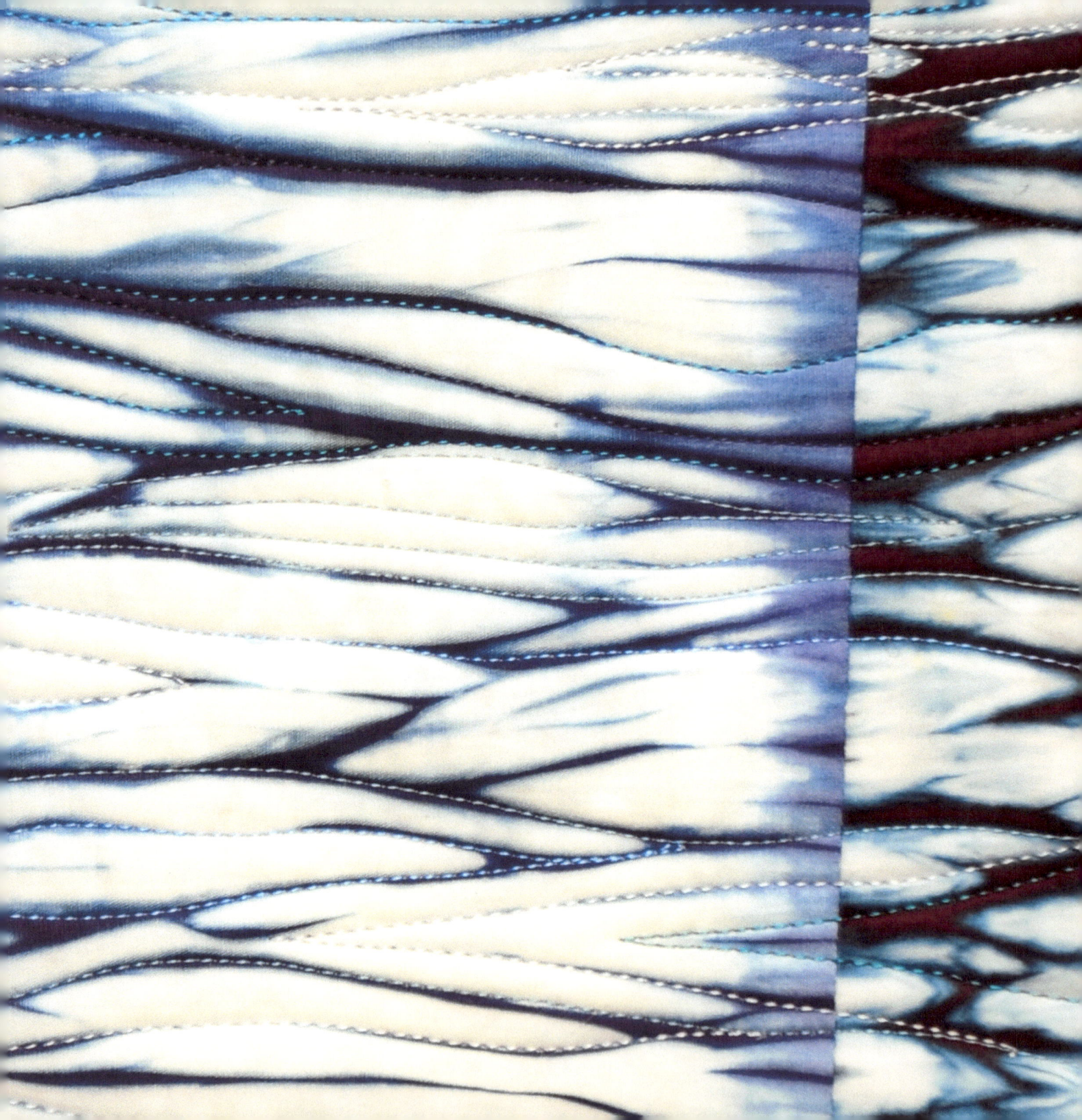

CHERYL GERHART

cgerhart@glen-eagle.com

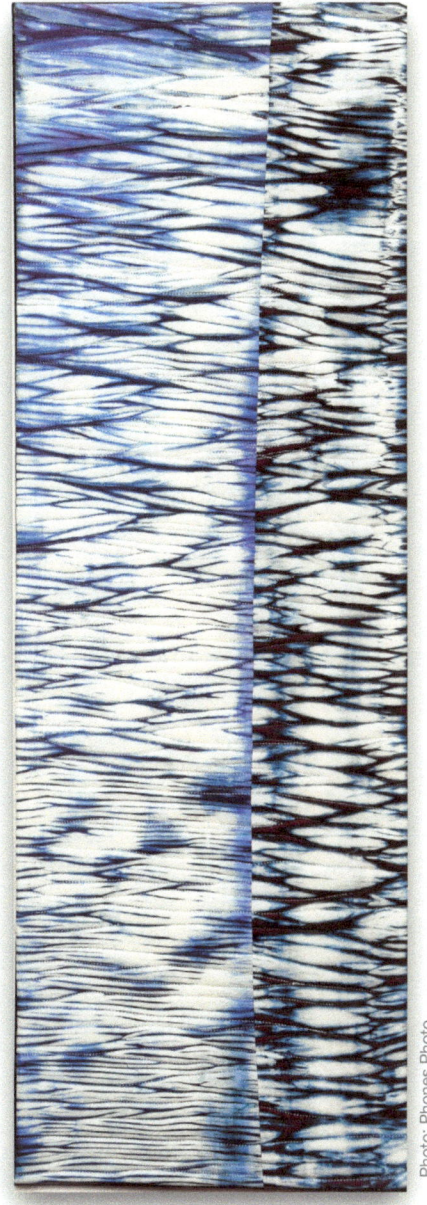

Ebb Tide

36"x12" cotton fabric dyed by artist, thread

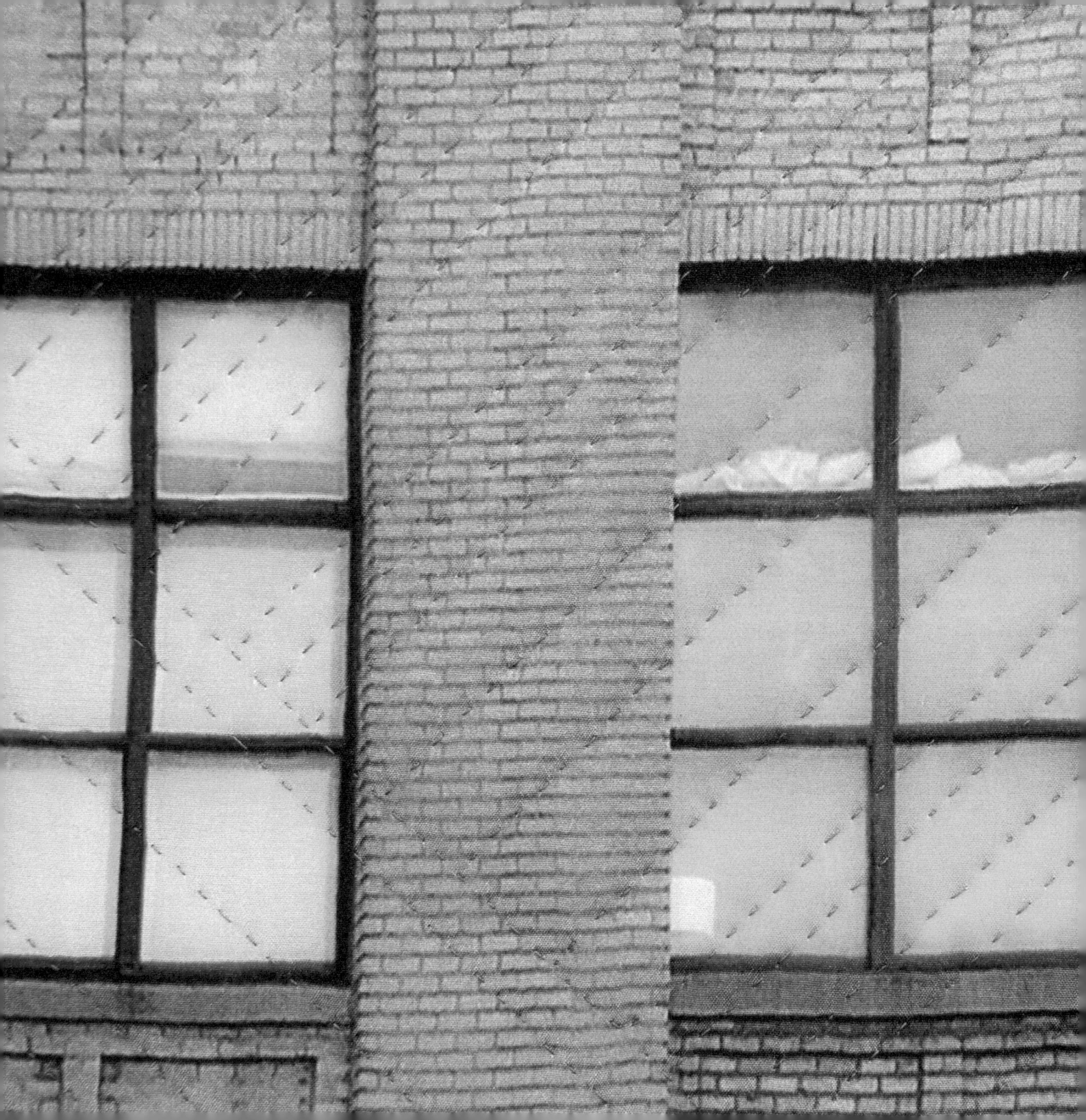

MARILYN HENRION

http://marilynhenrion.com marilynhenrion@mac.com

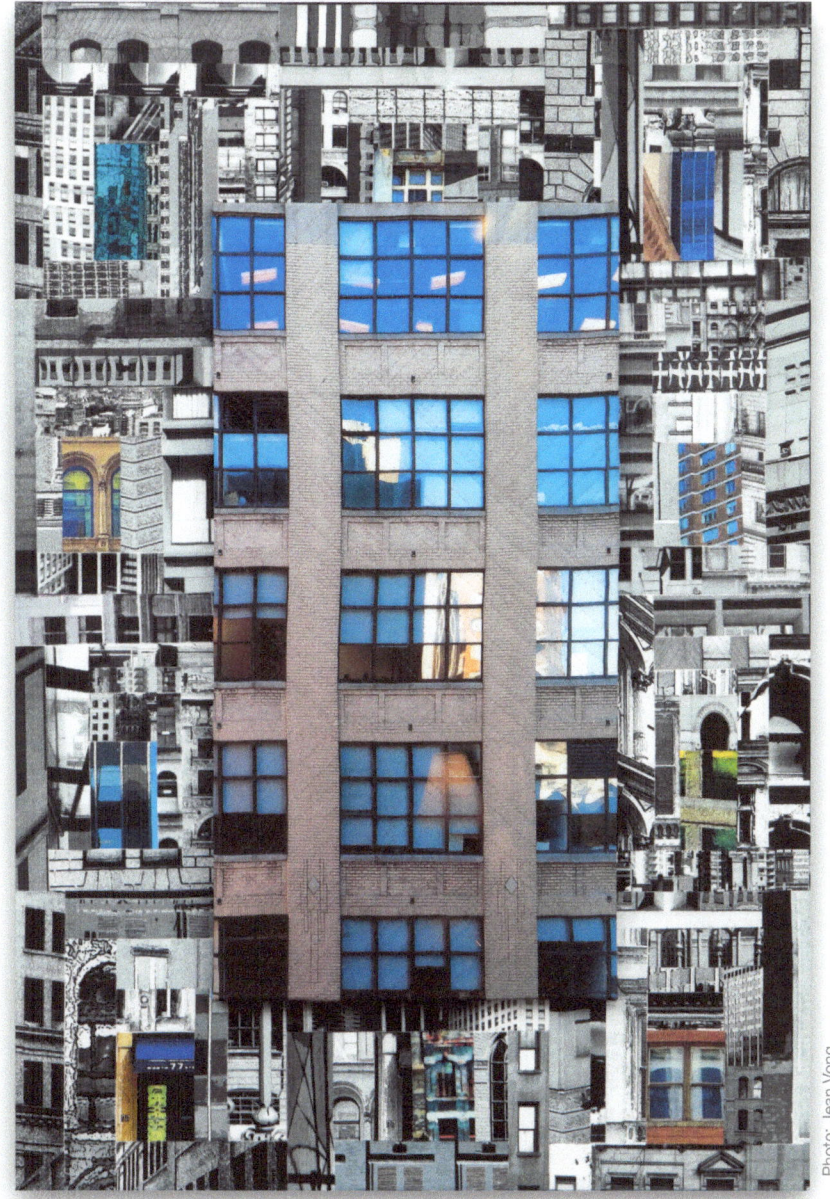

Patchwork City 28

36"x24": digitally manipulated photography, pigment printing on silk and linen, collage, hand stitching, silk thread

Photo: Jean Vong

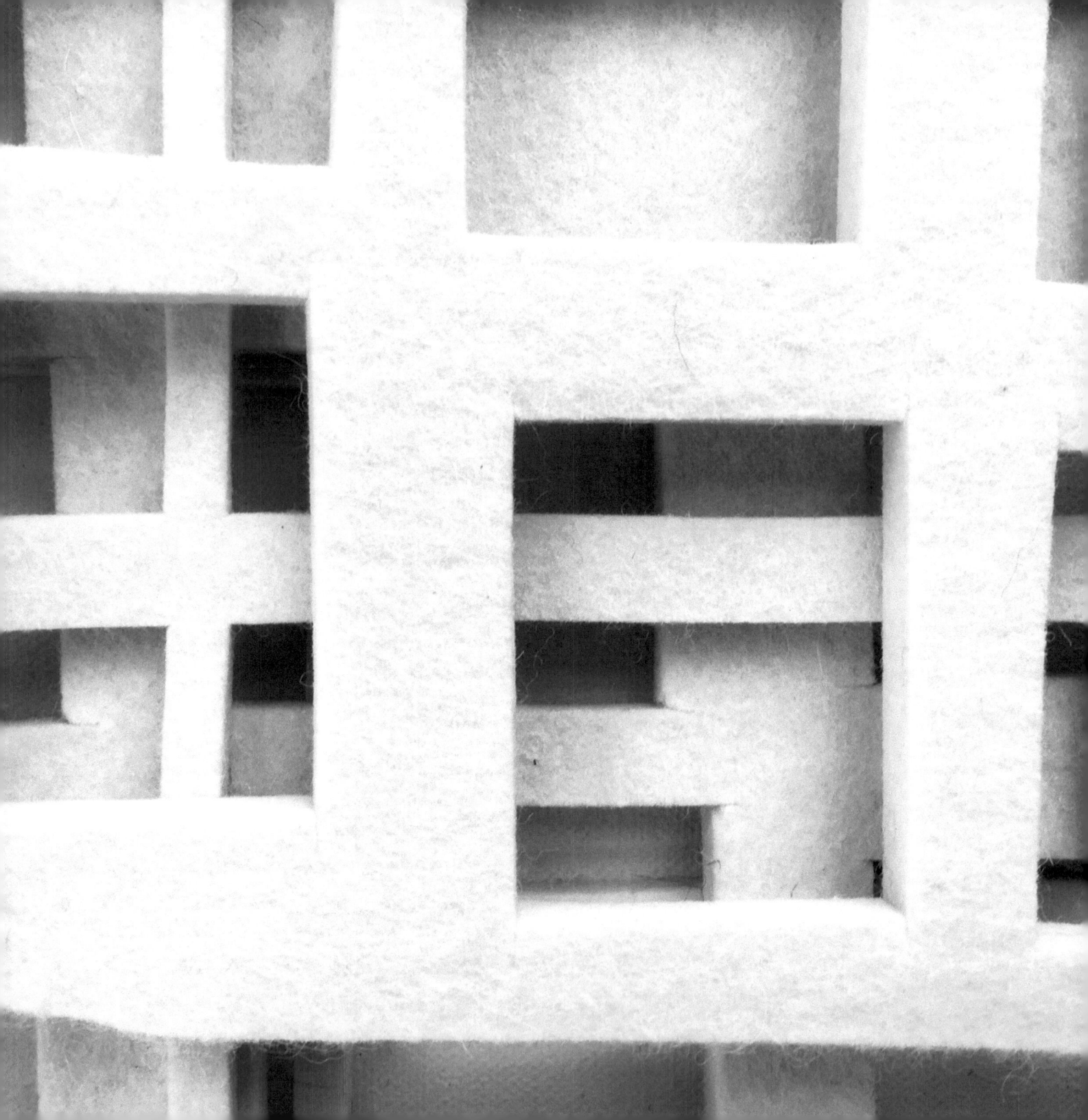

JULIA KIECHEL

http://jkiechel.com julia.kiechel@gmail.com

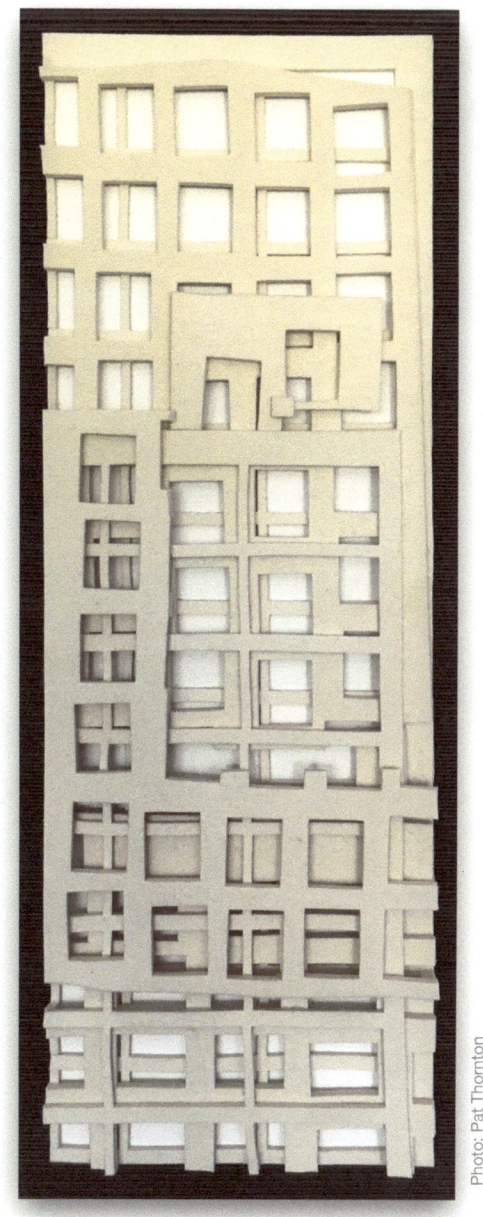

Photo: Pat Thornton

Outlook
36"x12" 100% wool felt

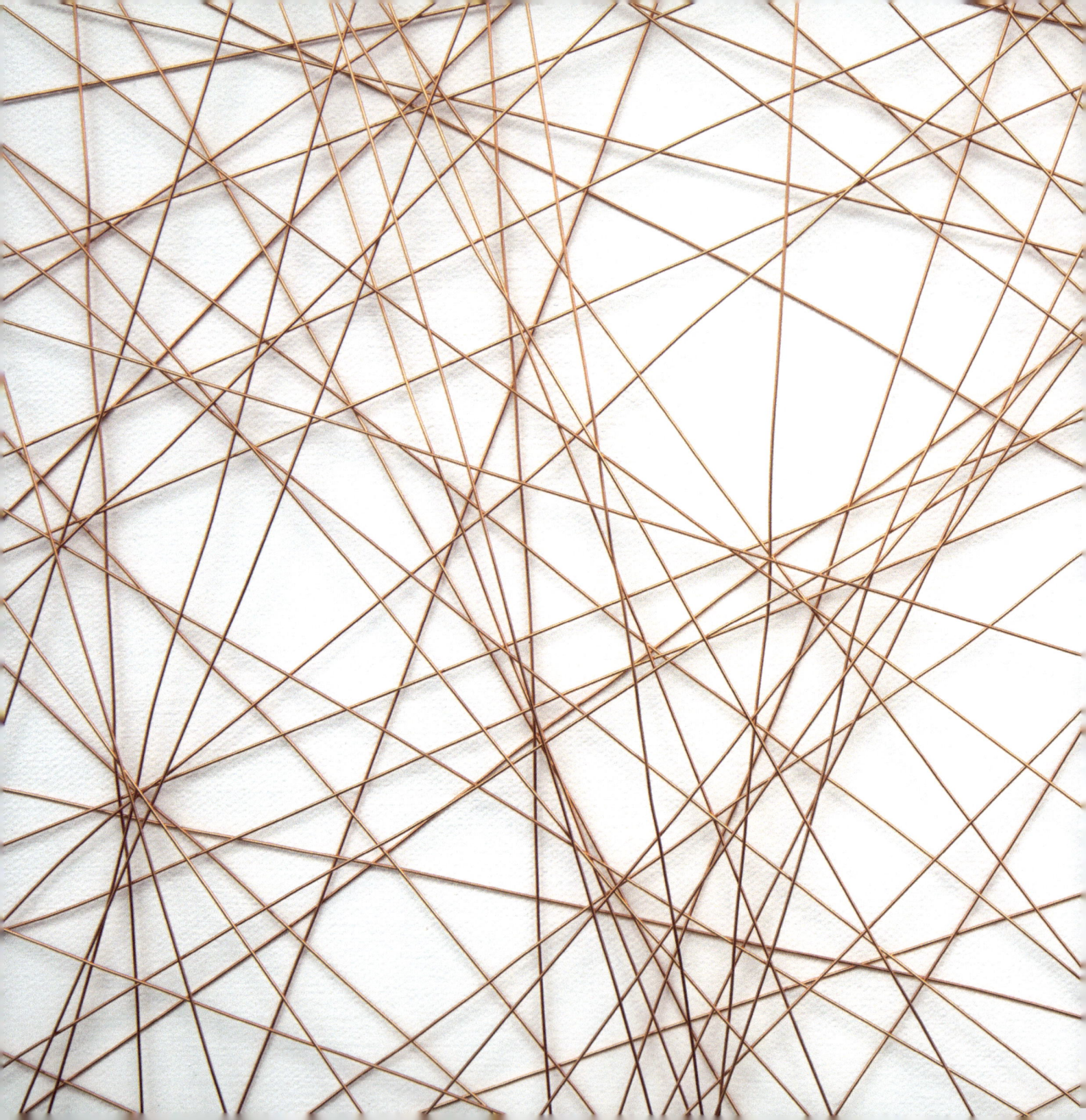

NANCY KOENIGSBERG

http://nancykoenigsberg.com .nancy.koenigsberg@gmail.com

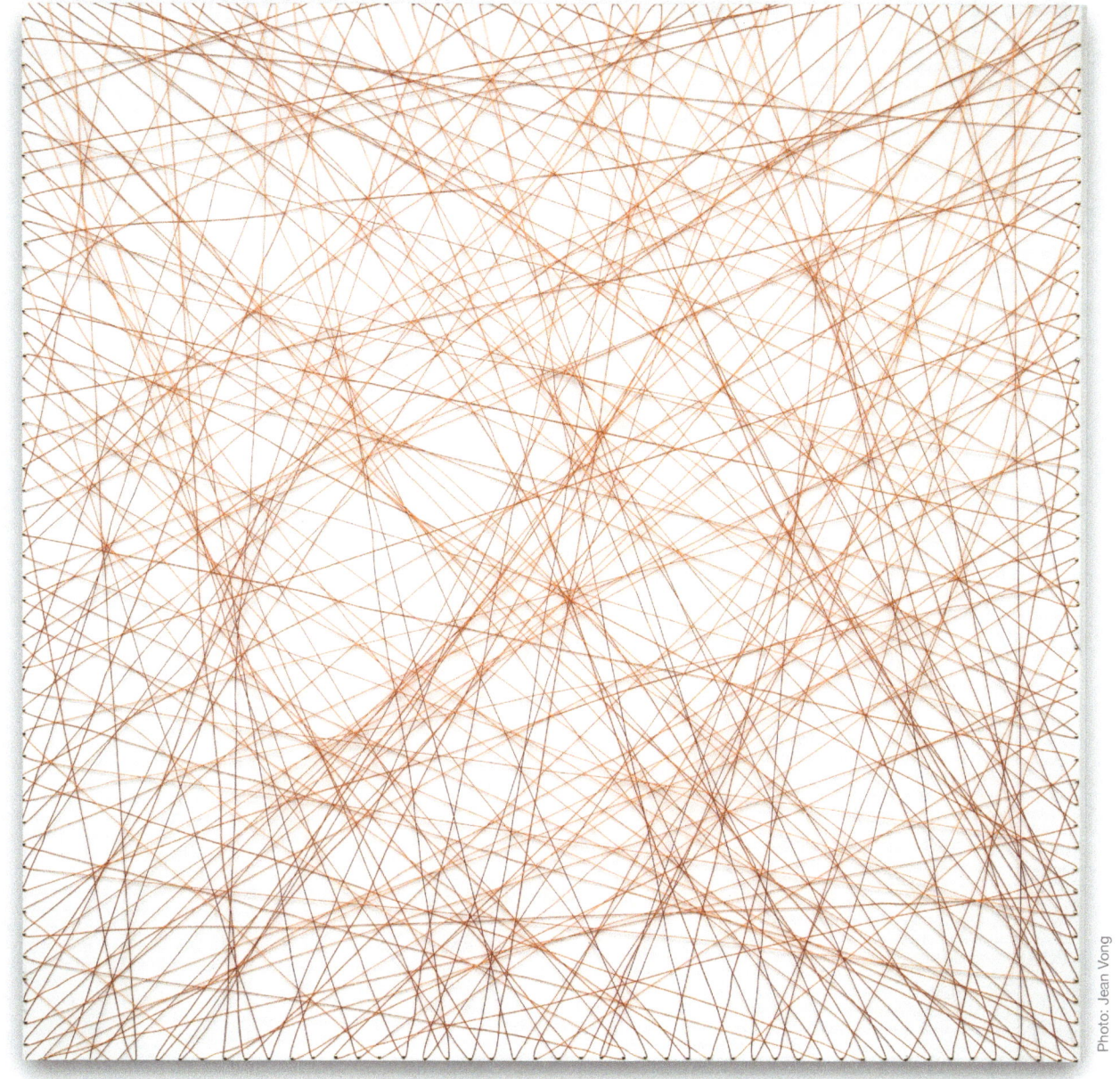

Crosspurposes

36"x36" coated copper wire, copper nails, acrylic on canvas

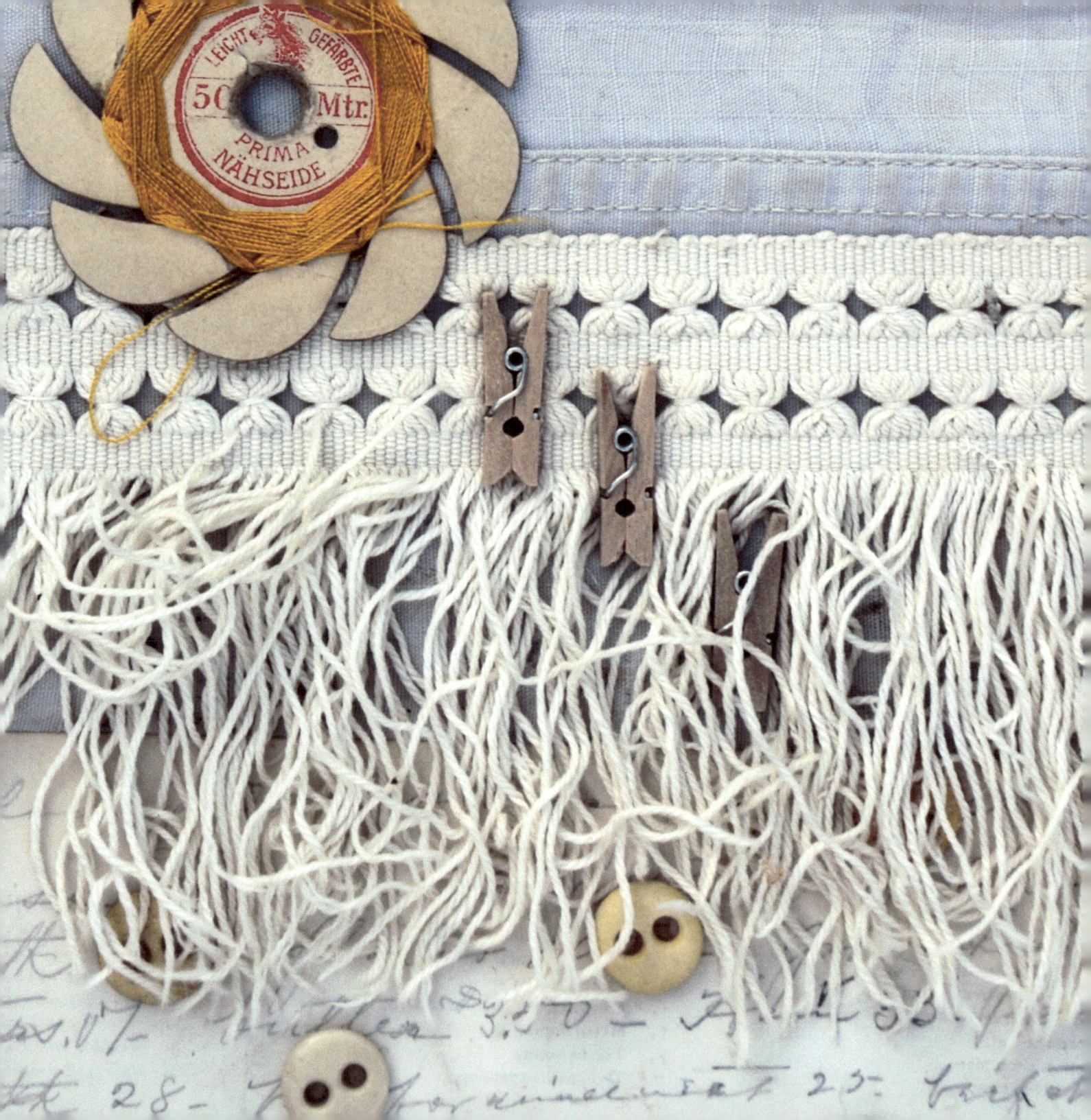

KATHRYN KOSTO

http://poetrycollage.com poetrycollage@gmail.com

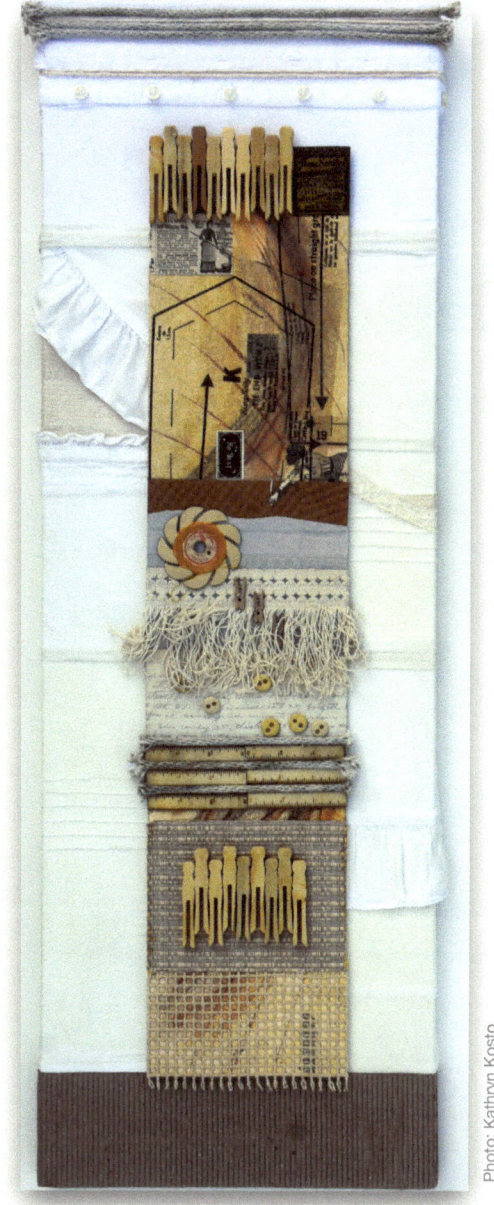

laundry list

36"x12" textile collage with clothesline, re-purposed clothing, sewing patterns, acrylic, pastel, buttons, findings,

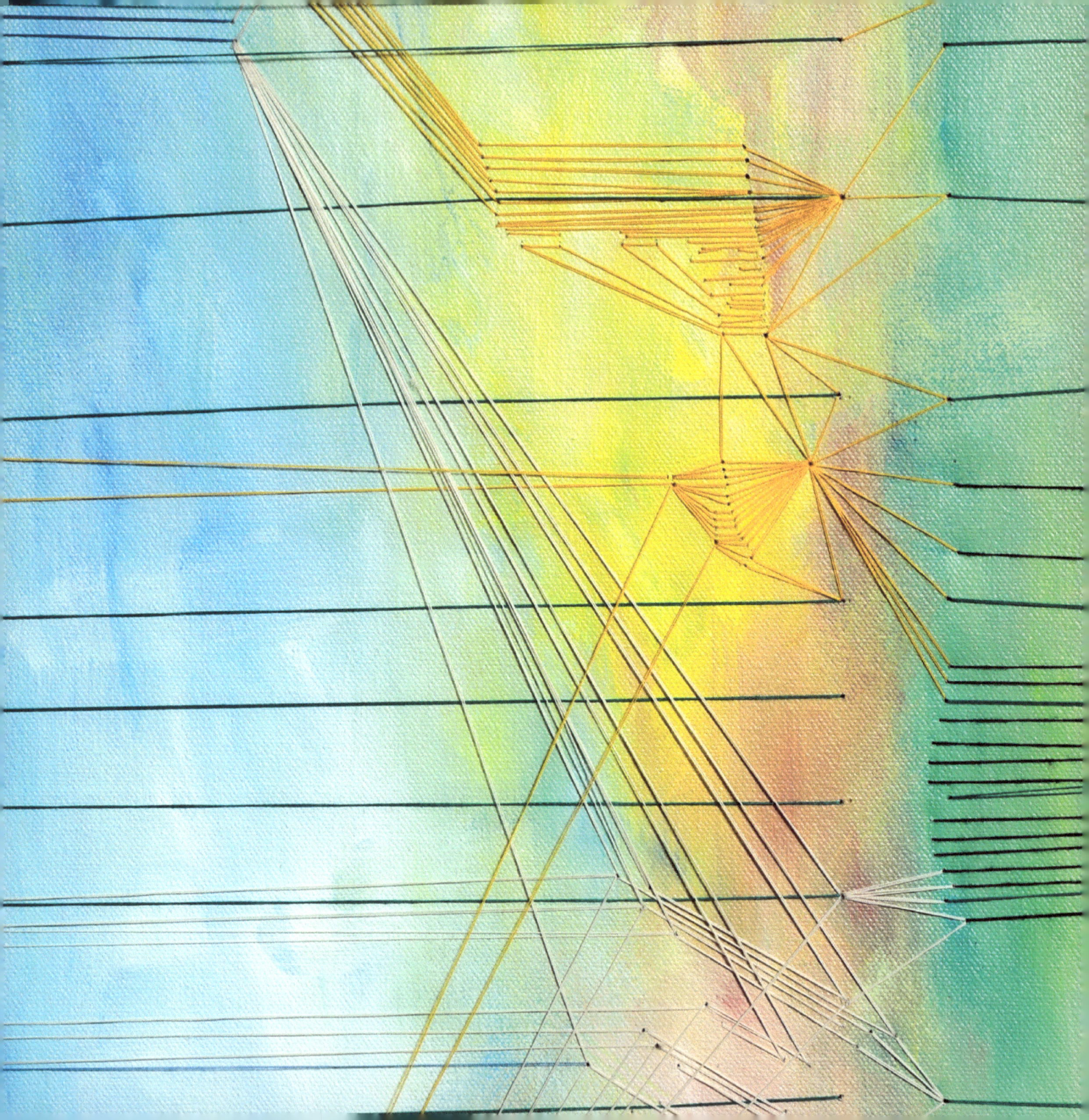

GAIL MILLER

http://gailmillerartist.com. gailmillerstudio@gmail.com

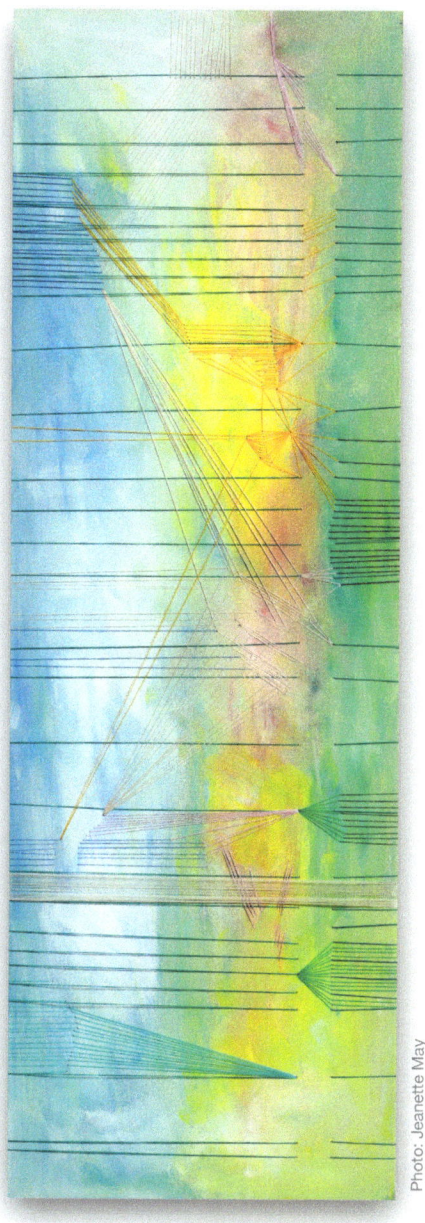

Photo: Jeanette May

Reflections of the Day

36"x12' canvas, acrylic paint, sewing thread

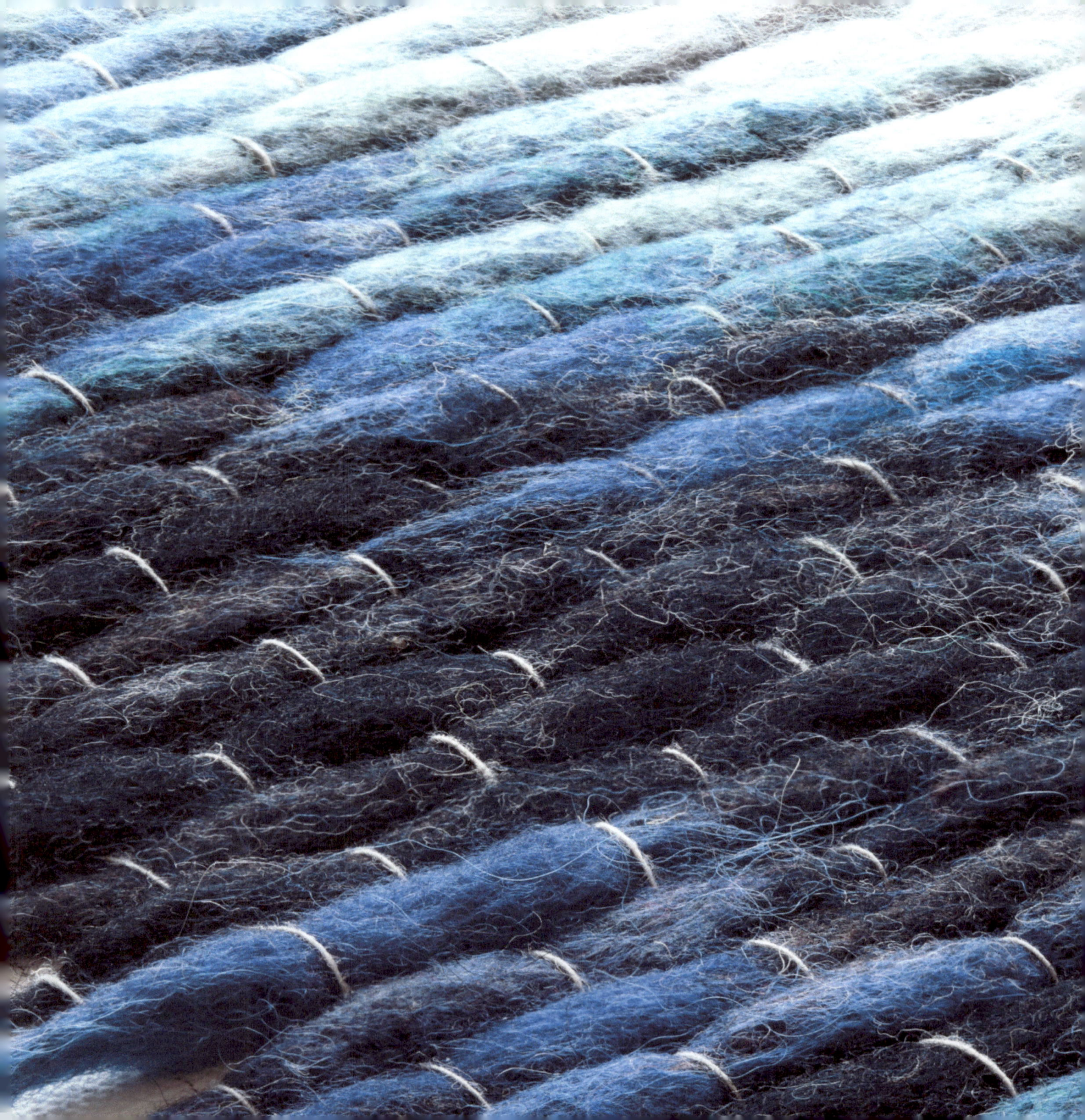

YASUKO OKUMURA
ok.yasuko@gmail.com

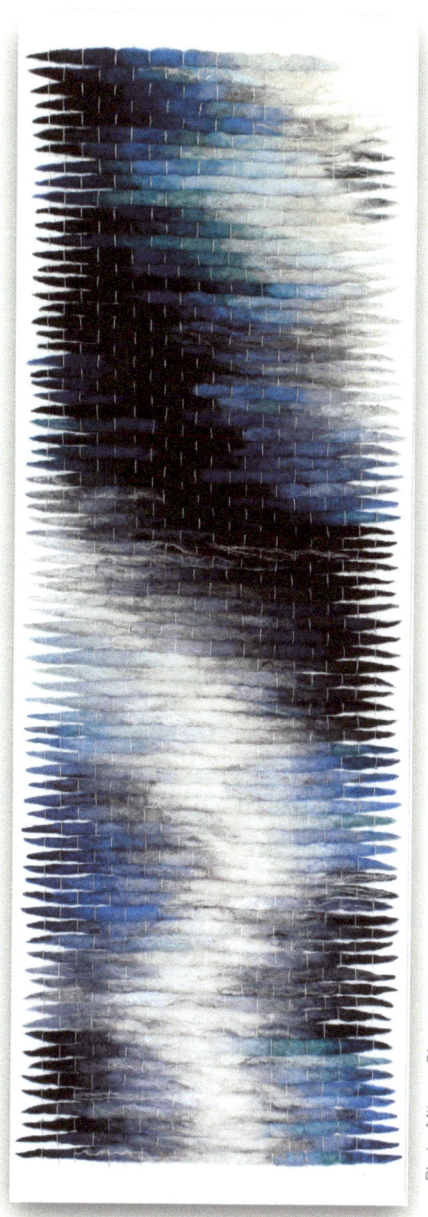

Photo: Mitsuya Okumura

Spirits in the Desert

36"x12' wool pre-felt, wool roving, polyester webbing, kenaf thread

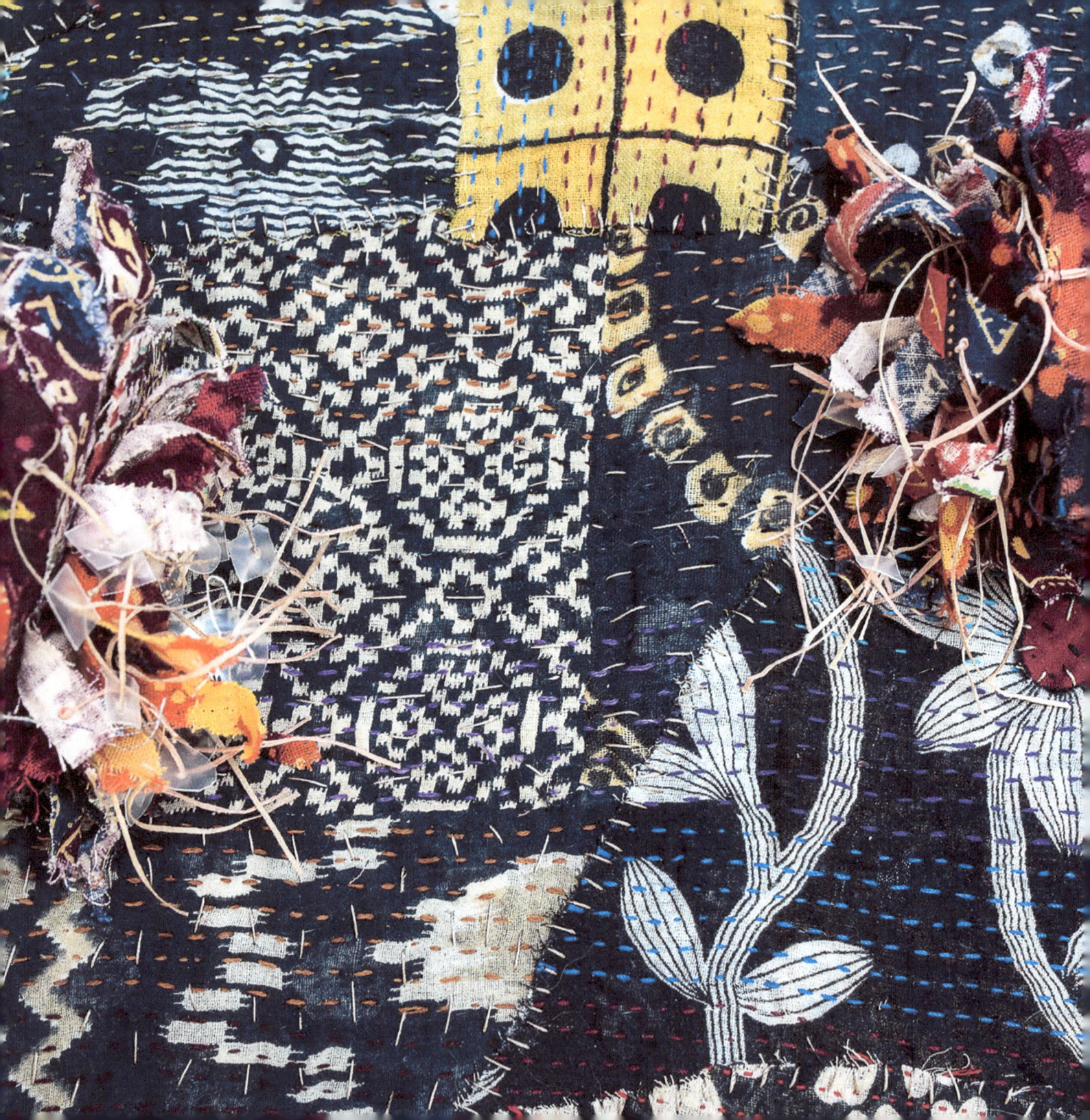

LINDA G. PARKER
FParker582@comcast.net

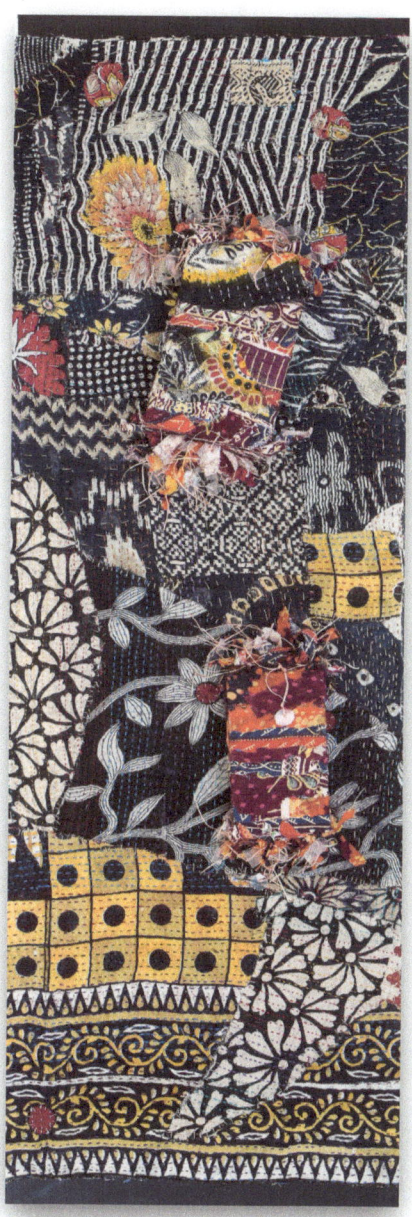

Belonging

36"x2" kantha cloth, cologne boxes, plastic packaging cut into square & round bead shapes

Photo: Amelia Panico

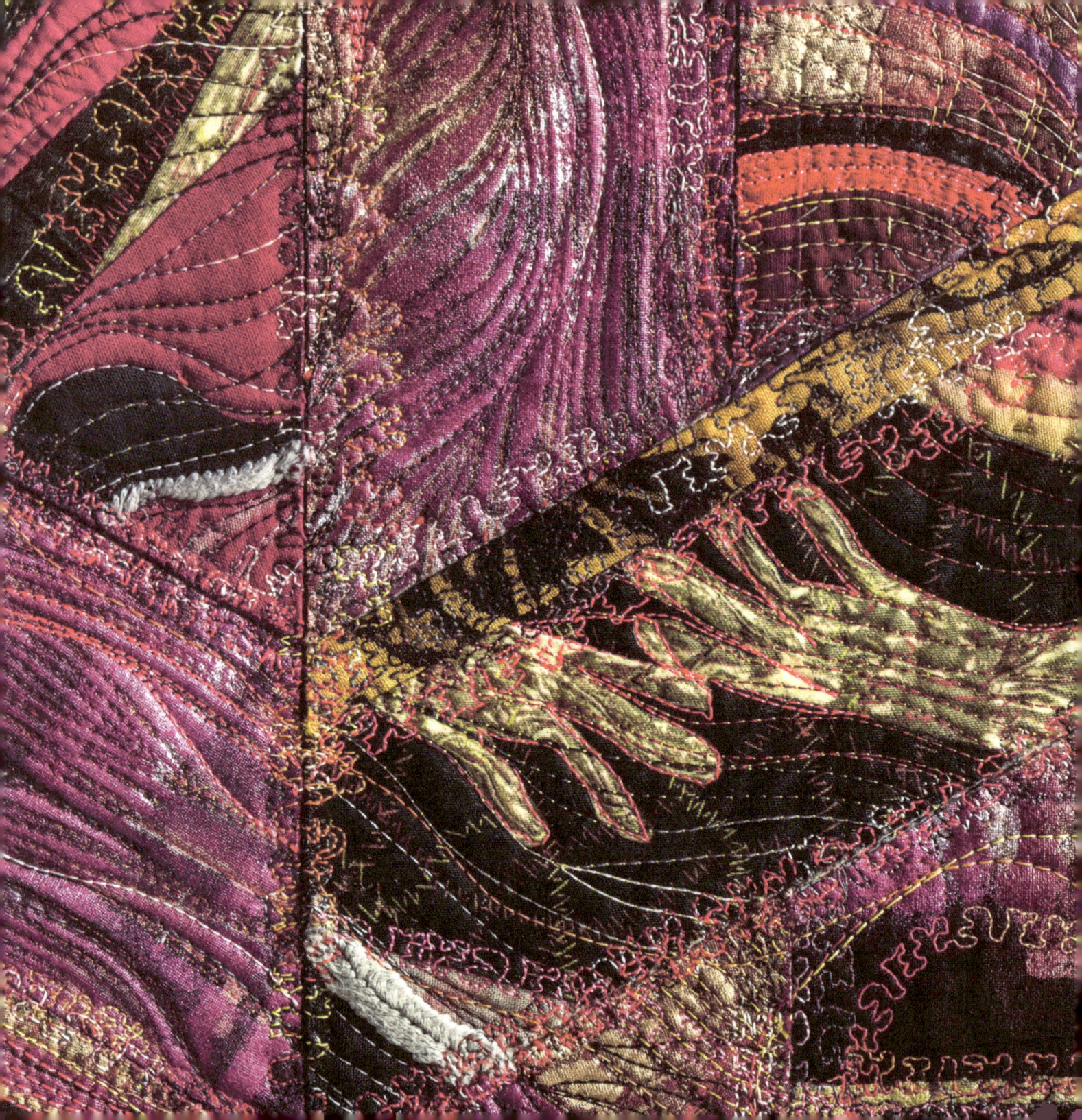

BARBARA SCHULMAN

http://barbaraschulman.com threadme2@gmail.com

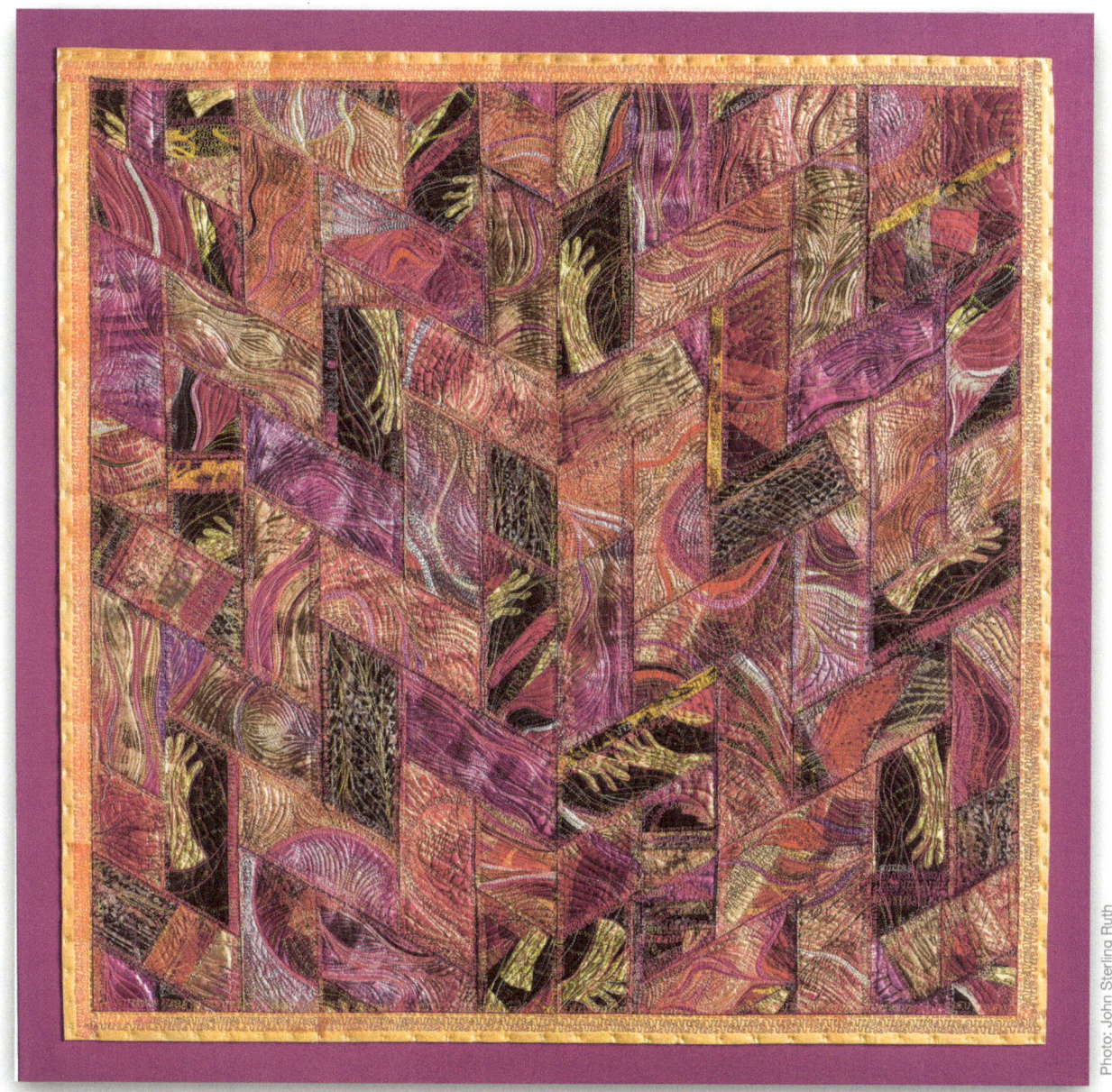

May Your Hands Always Be Busy

36"x36" quilts, batiks, discharged & overdid cotton & rayon, digital images, acrylic paint, hand & machine stitching

Photo: John Sterling Ruth

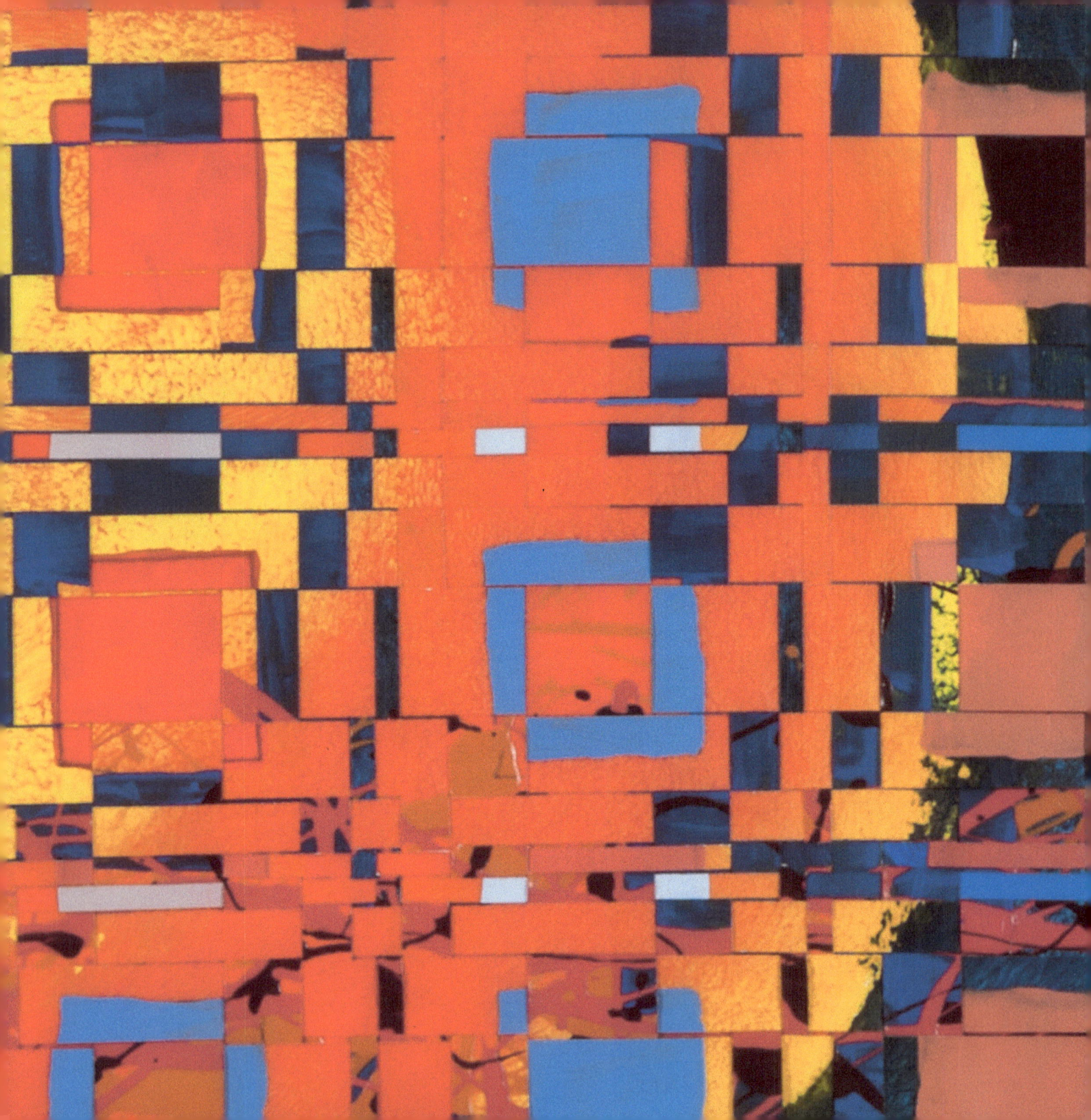

LARRY SCHULTE

http://larryschulte.com lschulte@aol.com

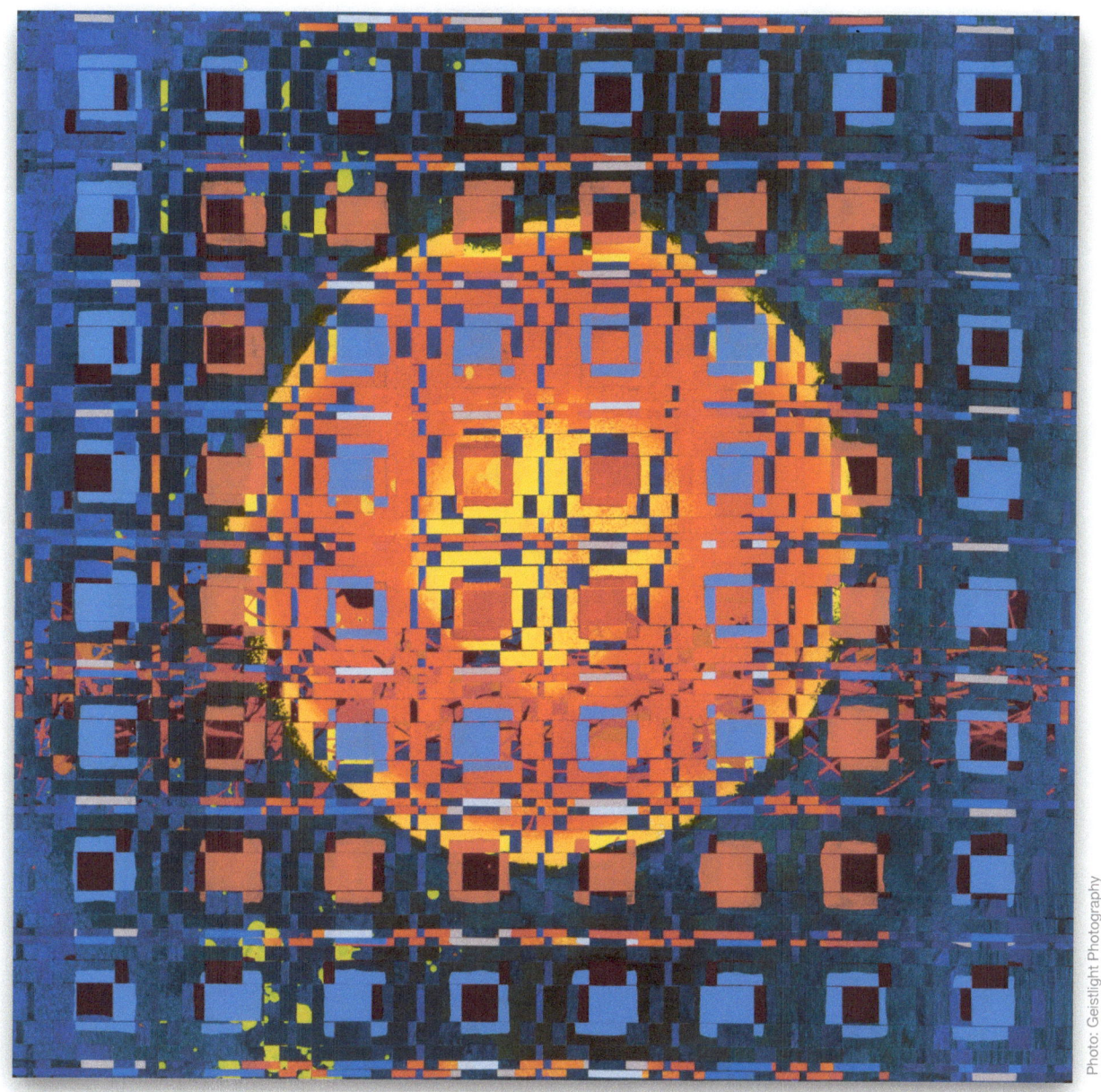

Colors of the Southwest

36"x36" acrylic paint on paper, cut in strips, woven

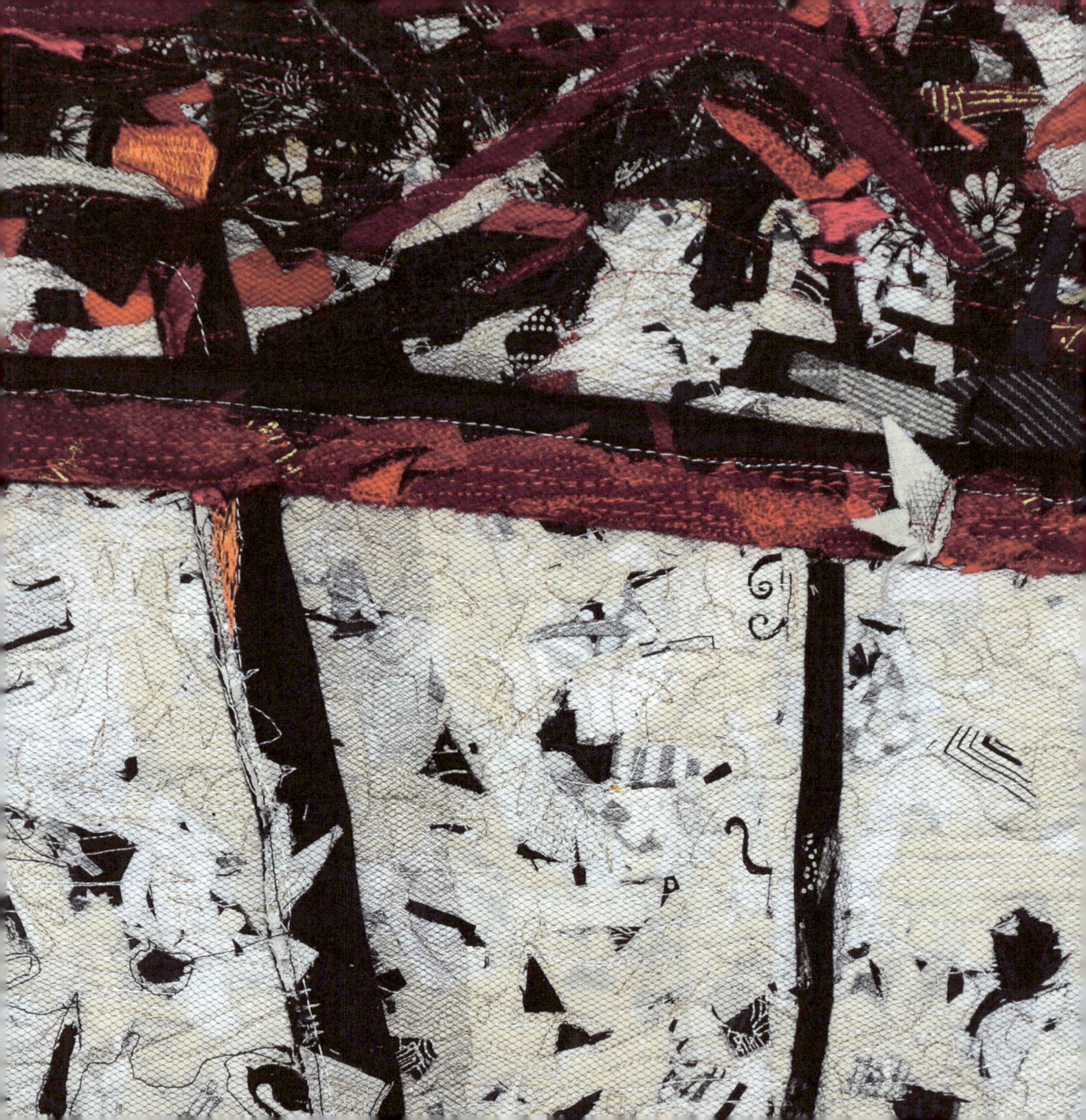

KIM SVOBODA

kimsvoboda@mac.com

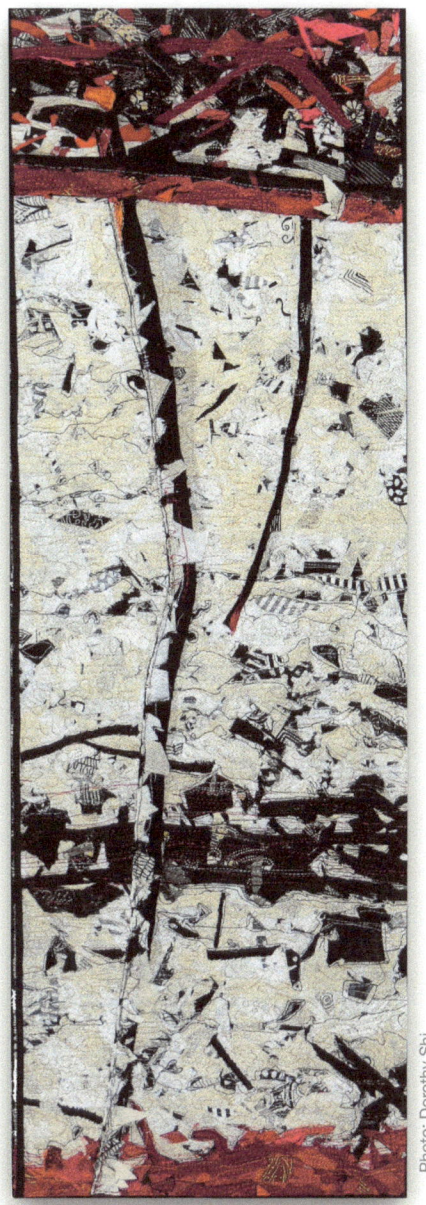

Photo: Dorothy Shi

Between Heaven and Earth

36"x12" wool felt, tulle, cotton, silk, thread, stretched canvas

tributaries
cradling
plump cities,
were merely
as we see
them now,

thin blue
veins
against an
ochre
surface,

RODICA TENENBAUM
rodica1.tenenbaum@gmail.com

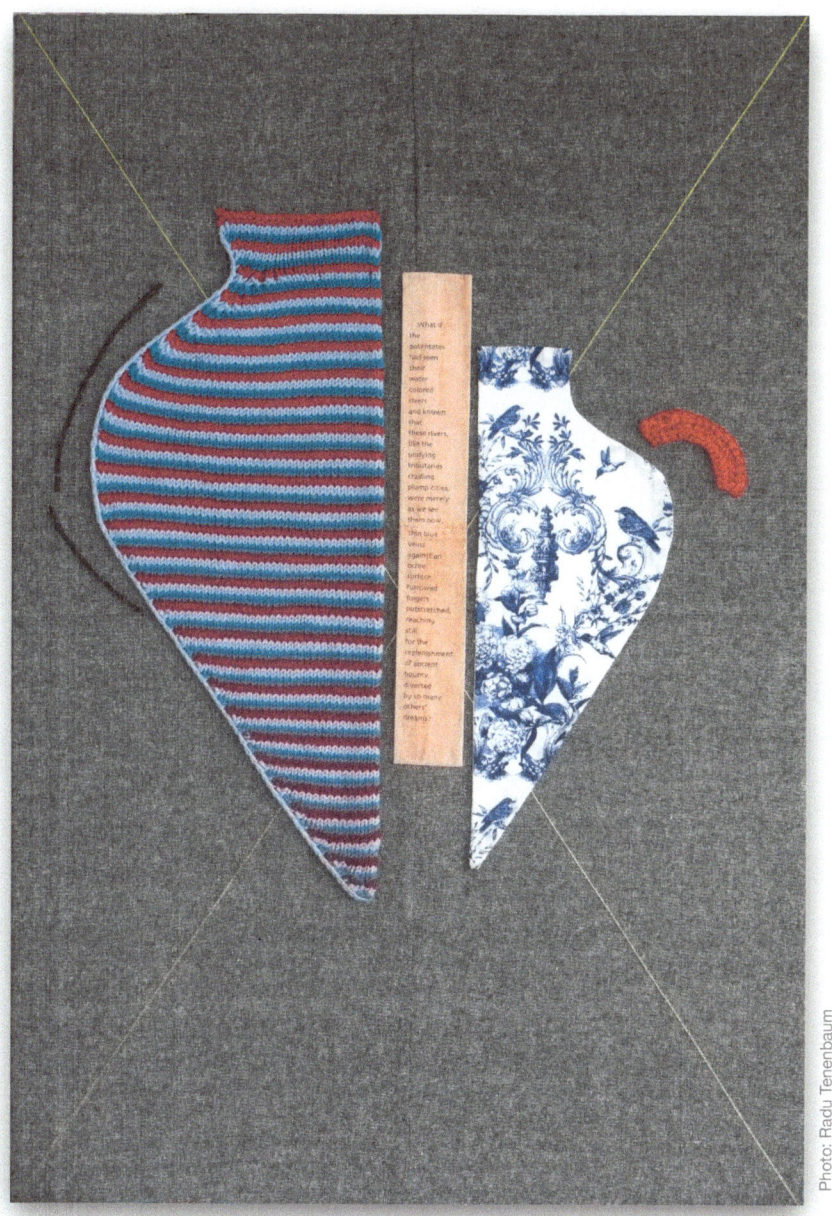

Shards

36"x24" wool, linen, cotton, twig, plastic bag, acrylic paint, thread, tulle

K. VELIS TURAN

http://kvelisturan.com kvelisturan@hotmail.com

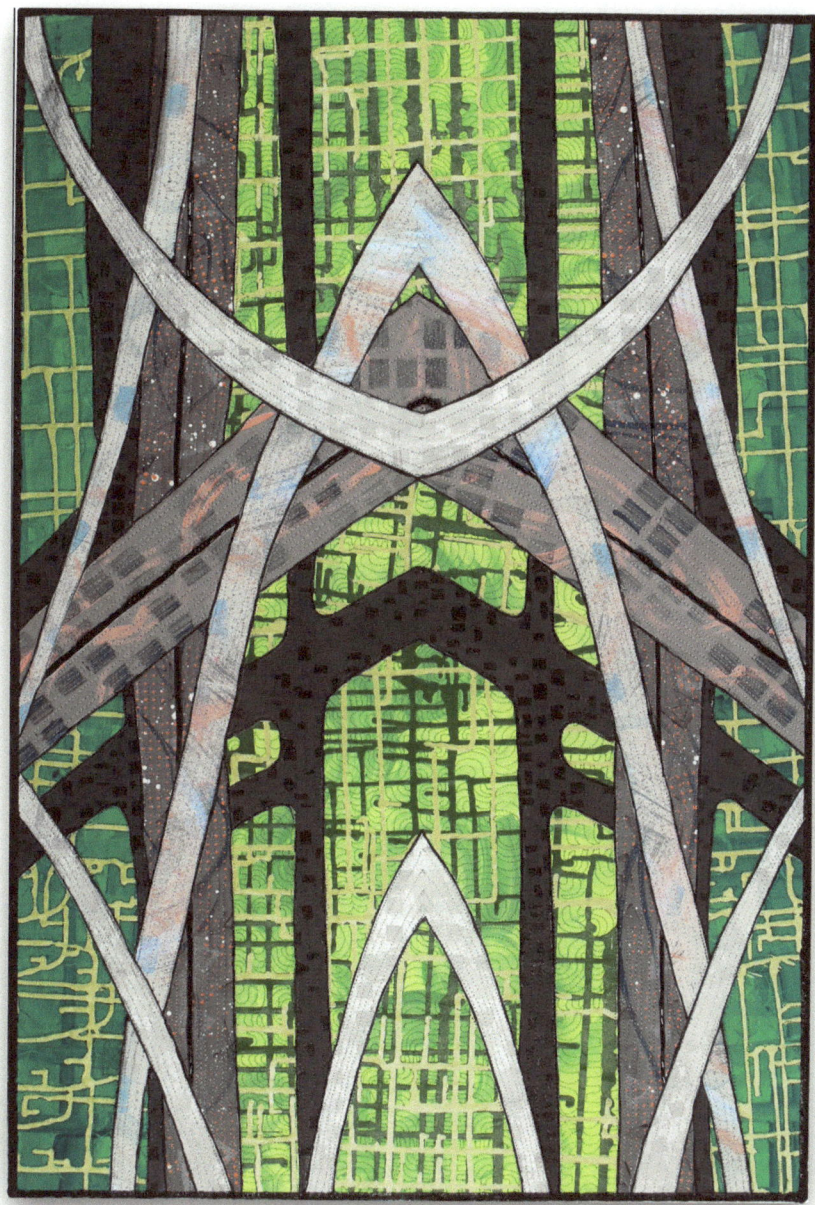

Intersections 12

36"x24" canvas, paint, thread, glass beads

Photo: Bob Turan

SAARALIISA YLITALO

http://saaraliisa.com saaraliisa@saaraliisa.com

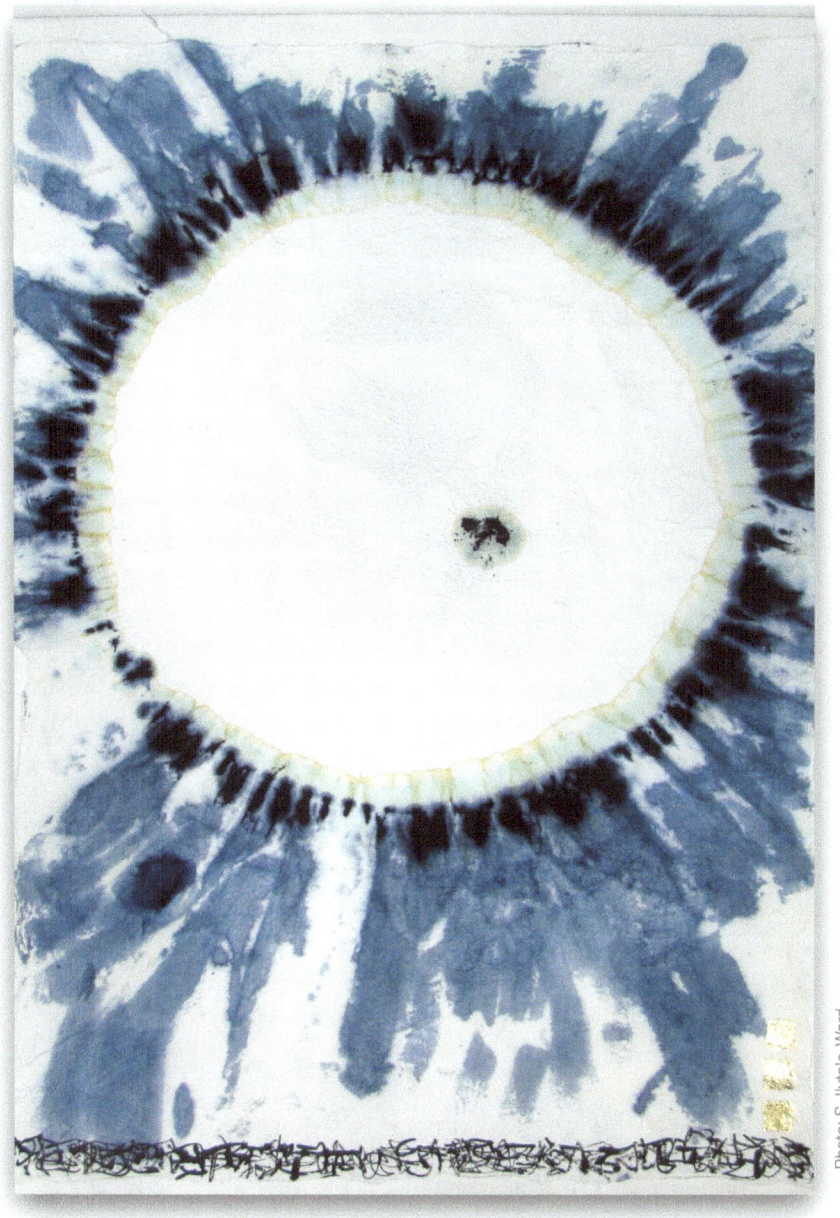

Empty
36"x24" mulberry paper, indigo dye, semi ink, gold leaf

VALERIE ZEMAN

http://valeriezeman.com valeriezeman@gmail.com

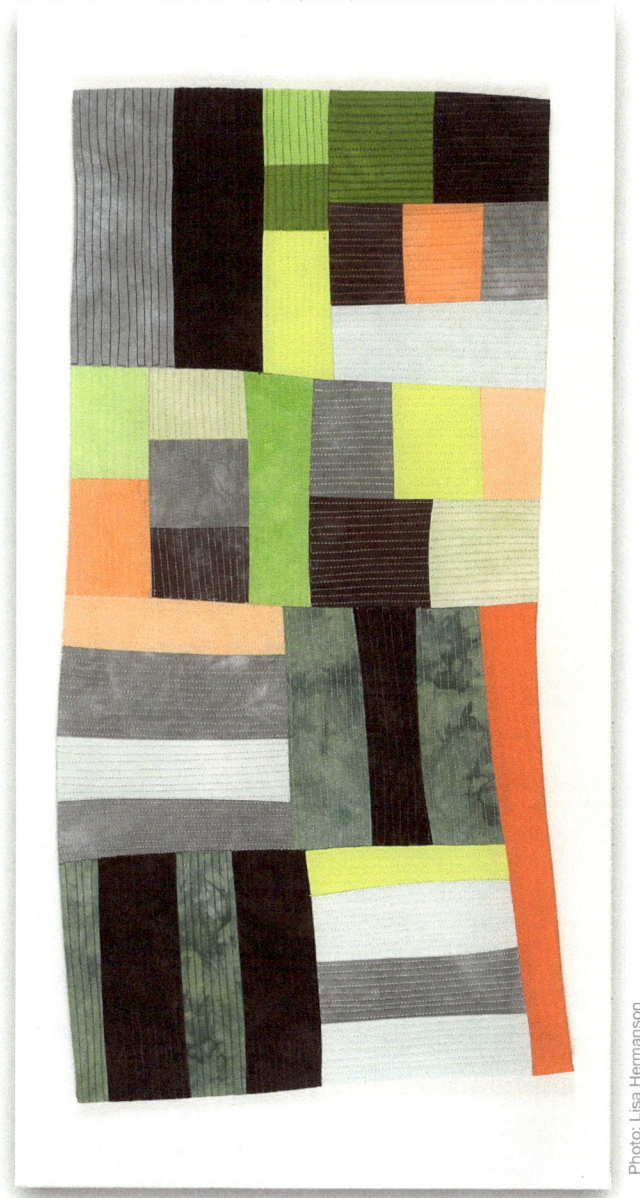

Photo: Lisa Hermanson

Summer Traffic

36"x18" hand-dyed cotton, freeform piecing, machine stitching

ABOUT TEXTILE STUDY GROUP OF NEW YORK

The Textile Study Group of New York, Inc. is a non-profit organization dedicated to to promoting a wider appreciation of fiber art among the larger art community and the public in general, and to supporting artists who share a mutual commitment to fiber as a medium for artistic expression. Founded in 1977 by a small group of artists to explore and expand their knowledge of the possibilities in the textile arts, monthly meetings were organized to share news, resources, criticism, and inspiration. Since then, the Textile Study Group of New York has grown to a membership of approximately 200, attracting a diverse range of members, including artists, arts professionals, collectors, conservators, curators, historians, teachers and writers. Programs include monthly speakers program, online members' gallery, member exhibitions, professional workshops, bi-monthly newsletter, studio visits, field trips, art student outreach program, and emerging artist fellowships. For more information, visit www.tsgny.org.

ABOUT CHASHAMA & THE VENUE

Chashama, which means "to have vision" in Farsi, nurtures artists by transforming underutilized properties into affordable work and presentation spaces for artists, performers, youth and community groups. The Durst Organization maintains a continuing program of support for the arts. By providing venues for exhibition in the lobbies of their buildings they strive to increase the presence of fine art and contribute to the cultural richness of the City. For more information, visit www.chashama.org.

ACKNOWLEDGMENTS

Exhibition Coordinator: Marilyn Henrion

Yard Works Juror: Janusz Jawarski, Chashama Program Director

Catalog Essay and Publicity: Kim Power

Catalog Design and Editing: Marilyn Henrion

Exhibition Support Team: Juliet Martin, Deborah Brand, Kim Svoboda, Gail Miller, Margaret Cusack, Ann Maurine Packard, Marguerite Wolfe, Nancy Koenigsberg, Pamela Koehler, Linda Parker

TSGNY Board of Directors: Marguerite Wolfe, President, Barbara Harris, Marilyn Henrion, Nancy Koenigsberg (President Emeritus), Lisa Lackey, Elaine Longtemps, Barbara Maxey, Kim Svoboda

Thank you to Chashama and the Durst Organization for providing the exhibition venue and for their continuing work in support of the art community.

www.ingramcontent.com/pod-product-compliance
Lightning Source LLC
Chambersburg PA
CBHW050811180526
45159CB00004B/1624